Thank You

NAMES IN ORDER OF APPEARANCE

Alicia Hannah
Danielle Orsino
Kimberly Douglas Madison
Maria Portman Kelly
Leah Henoch
Cassie Silva
George Robert
Lauren Sevigny
Lindsey Rider
Ferren Farrah
Britany Middleton
Sophie Zucker
Major Novogratz
Christy Altomare
Opeyemi Olagbaju
Kantu Lentz
Alexa Rauch
Natalie Lander
Josh Breckenridge
Laura Hall
Sungmi Choi
Gemma Brown
Amy Berryman
Kai Hazelwood
Rachel Baumgarten
Travis Madison
Christine Krumme
Gilbert Sanchez
Chris Redd
Jennifer Bowles
Madeleine McKenzie
Karissa Conner
Alessa Neek
Anna Konkle
Courtney Nightingale
Hiko Mitsuzuka
Jenna Robino
Elliot Finkel

Kim LaVere
Christopher Reid Lee
Nicole Sousa
Lauren Farrah
Brynn Shiovitz
Will Chang
Shaun Sutton
Lexie Ruse
Matt Emert
Neha Raghavan
Yael Borensztein
Tiffany DeLeon
Jami Goldman-Marseilles
Lorabeth Barr
Nikki Isordia
Lyssa Mandel
Jennifer Temen
Frankie Verroca
Arianne Villareal
Dewayne Perkins
Michaela Johnson
Zain Pirani
Naomi Nwadiwe
Jordan Ambrosino
Mercedes LeAnza
Dierdre Lorenz
Kearran Giovanni
Shauna Goodgold
Adrien Finkel
Gabrielle Perez
Michelle Kurth
Kally Duling
Jennifer Larkin
Nadira Foster-Williams
Kaila Hill
John Berring
Lynda DeFuria

Rick Kariolic
Joy Lanceta
Alexander Rose
Tasheena Medina
Sarah Schenkkan
Hailei Call
Moonlynn Tsai
Sara Emami
Danny Casillas
Tallulah Novogratz
Antoinette Tarabay
Lindsey Freeman
Amanda Perez
Kaitlyn Davidson
Ellen Ancui
Jesse Manocherian
Lizzie Weiss
Elijah Funke
Francesca Granell
Joey Pollari
Ariel Fisher
Chloe-nil Acerol
Leola Bermanzohn
Arnold Rosenfeld
Amanda Glaze
Kelsey Ketzner
Aurora Simcovich
Anna Greenfield
Courtney Halford
Callie Cleaves
Annie Hendy
Brittany Thompson
Jaygee Macapugay
Larry Emert
Brian Golub
Mara Herman
Rebecca Southgate

Yin Chang
Stephanie Martignetti
Charlie Hoffman
Dione Kuraoka
Sara Amini
Mitchell Walker
Mikhail Roberts
Ann Samuelsson
Aviva Funke
Hayley Marie Norman
Sara Hass
Lucy Hass
Rebecca Kahn
Felix Kahn
Guy Reiss Gandell
Peyton Ambrosino
Penelope Vandenberg
Koen Vandenberg
Juliana Calloway
Helene Feldman
Jillian Shields
Fox Reiss Gandell
Lisa Steen
Rachel London
Ellyn Jameson
Illene Rosenfeld
Esma Deljanin
Lily Thaisz
Stephanie Gibson
Laura Jean Anderson
Colleen Ladrick
Ben Newell
Sean Montgomery
Alison Sluiter
Jemma Ancui Lawler
Alexa Green
Sarah Davenport

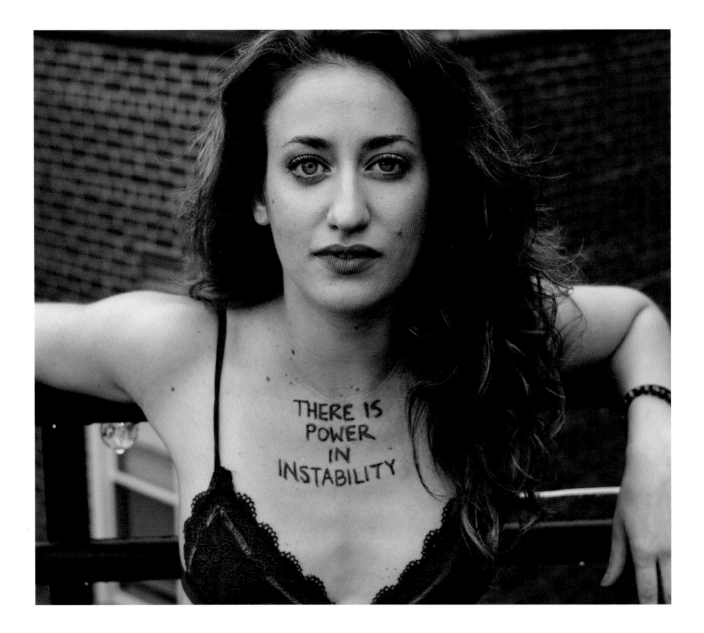

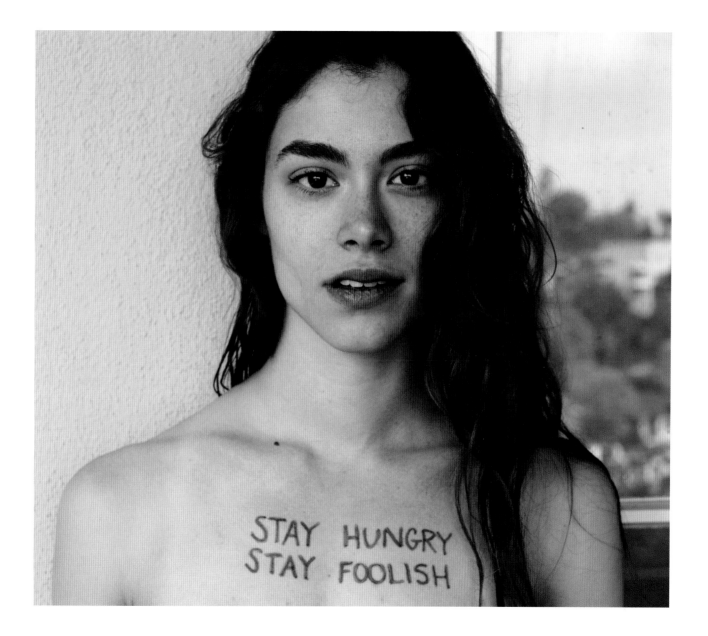

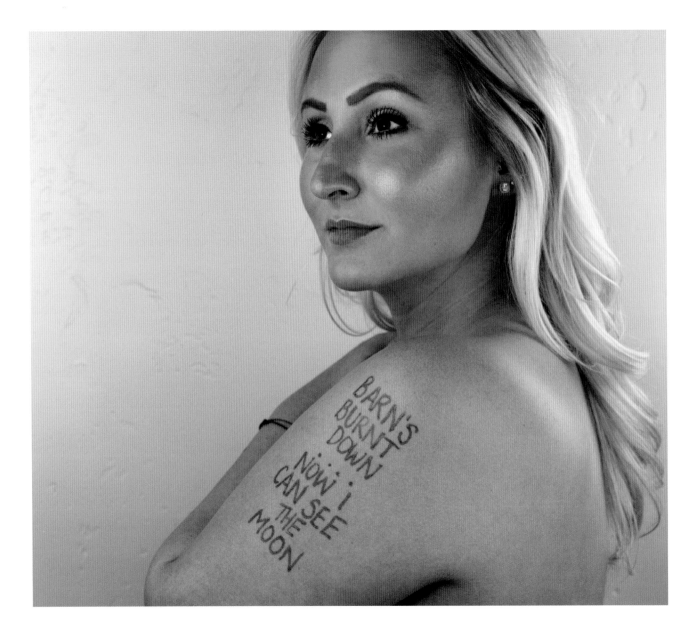

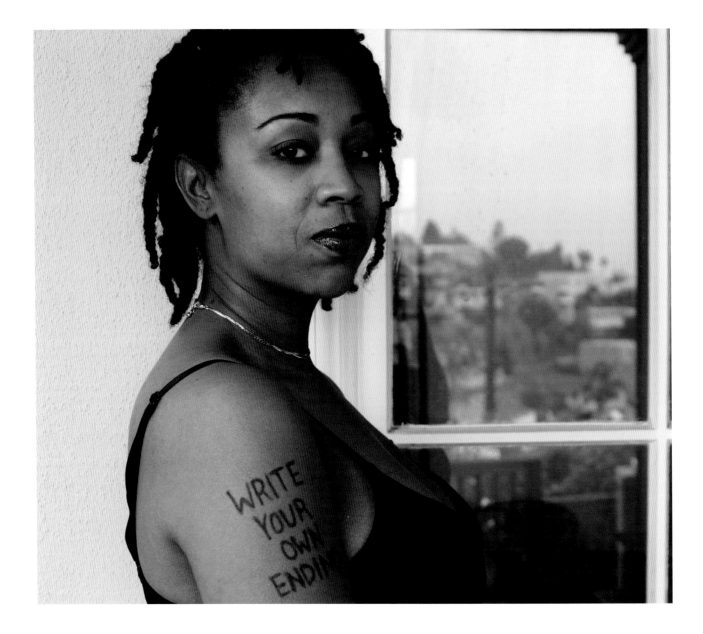

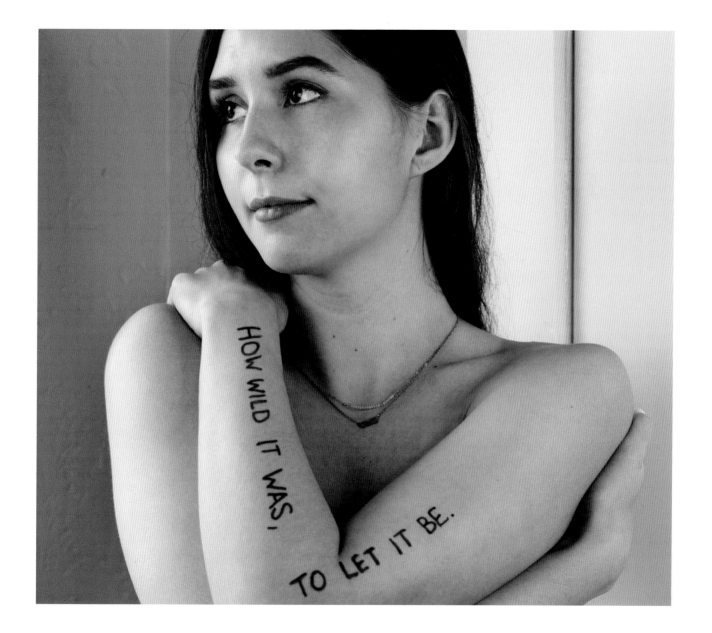

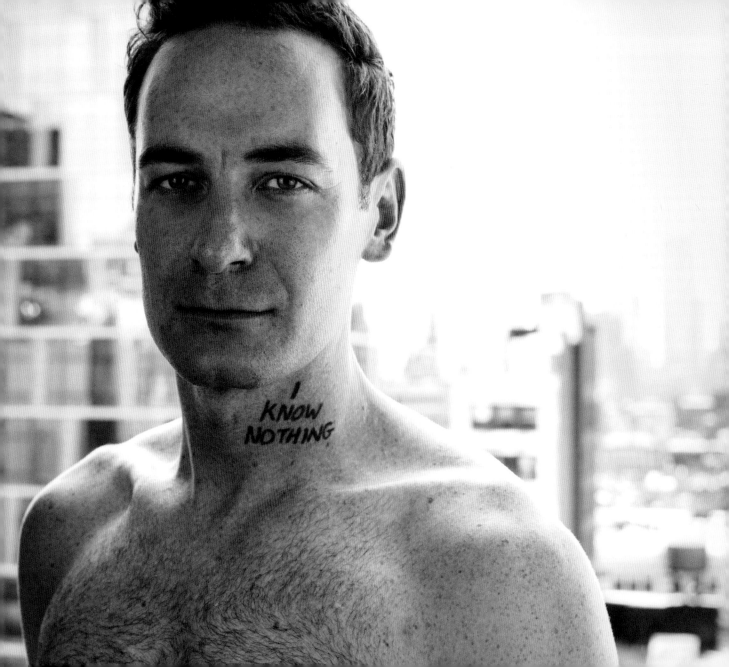

I'VE ALWAYS BEEN A BIG FAN OF ORDER AND STRUCTURE.

When things don't work out the way I hoped or intended or planned, it is hard for me not to take it personally, and letting that go is not something that comes easily to me. However, I have come to believe that the universe has its own plan. It gives you exactly what you need, when you need it, but it isn't always pretty. Accepting that I know nothing gives me the freedom to experience *everything*. As it is. Right now. Without my preconceived ideas or judgments, and whatever it is … it's beautiful.

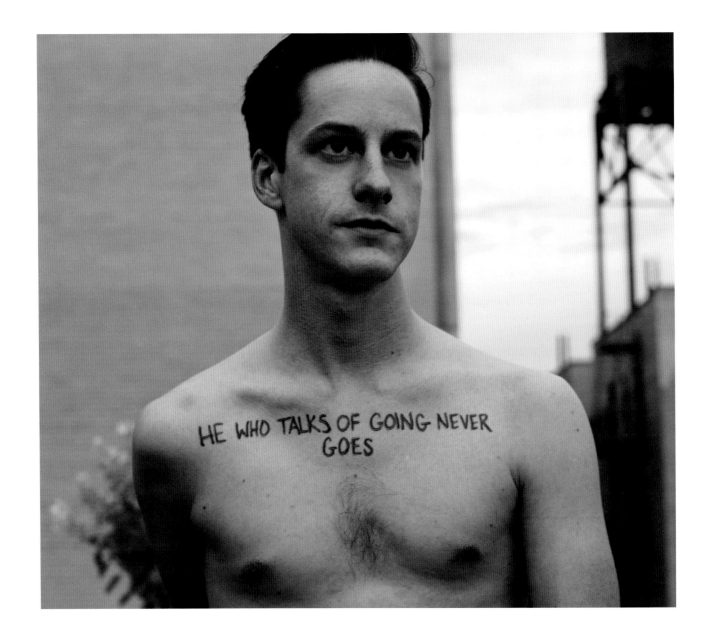

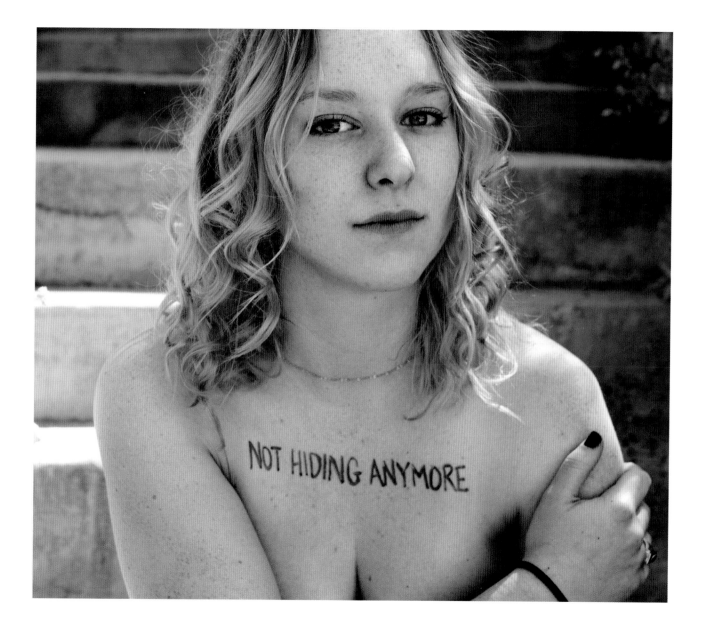

You say shut it, I'll speak loud

You say take it, I'll rip it up proud

I don't regret it when my heart's all out

Silence won't help me now

You say fake it, I'll bring the truth

You say close it, I'll open up to you

I've got nothing more to hold on to

But silence won't help me through

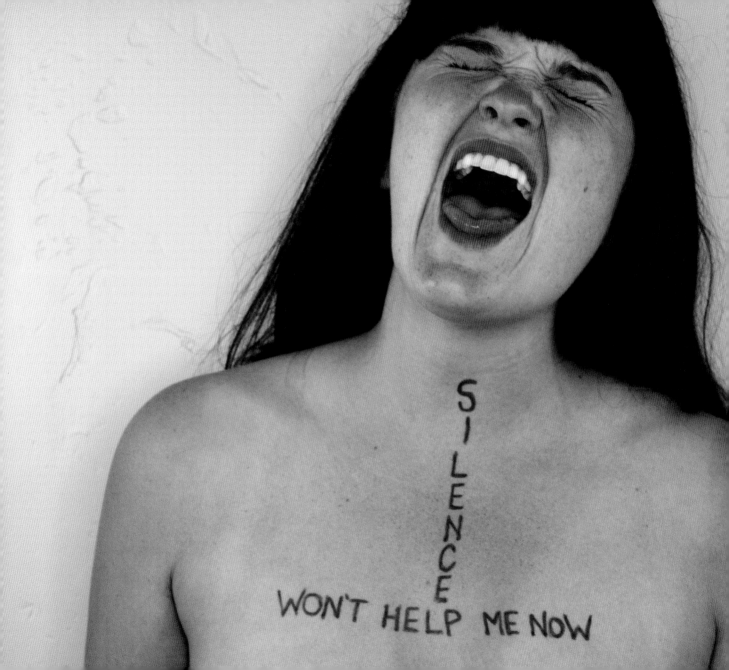

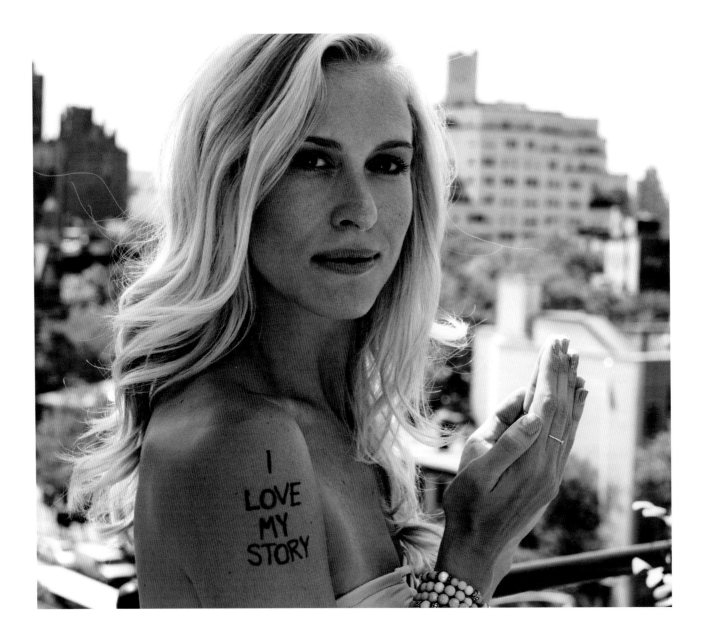

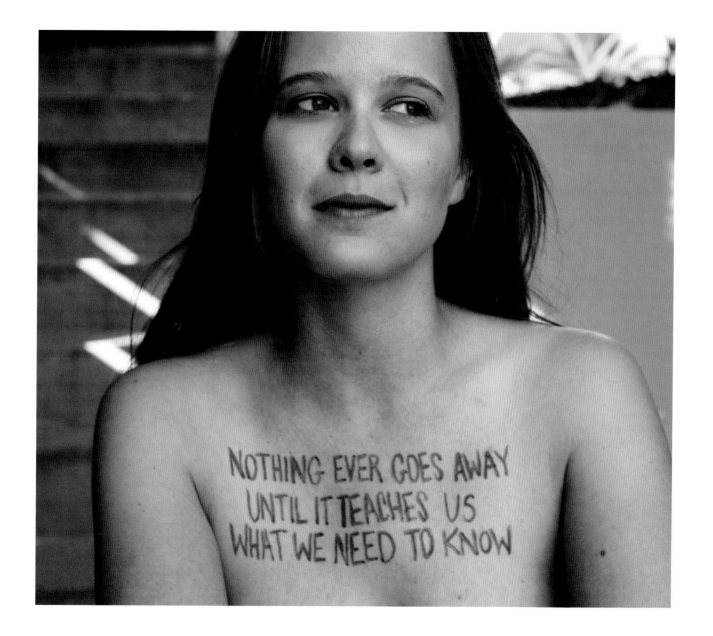

IT TOOK ME A LONG TIME TO REALIZE
THAT BEING LIKED ISN'T AS IMPORTANT
AS ME LIKING MYSELF.

In reality, I have no control over what people think of me. Being myself brings me greater joy, deeper relationships, and the respect I had hoped for when I had compromised myself in order to be liked.

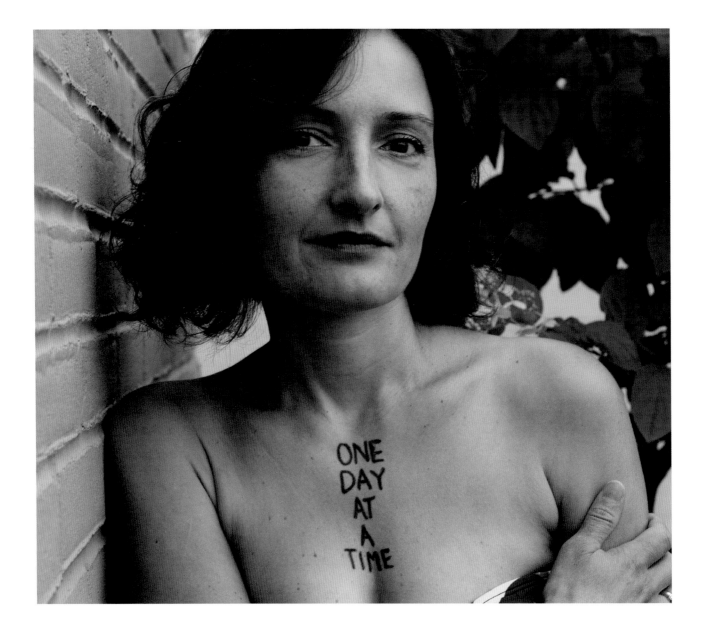

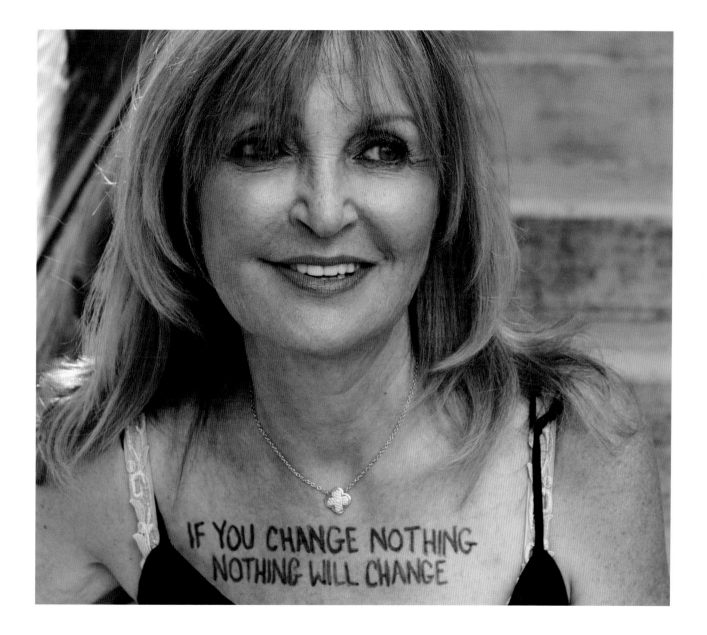

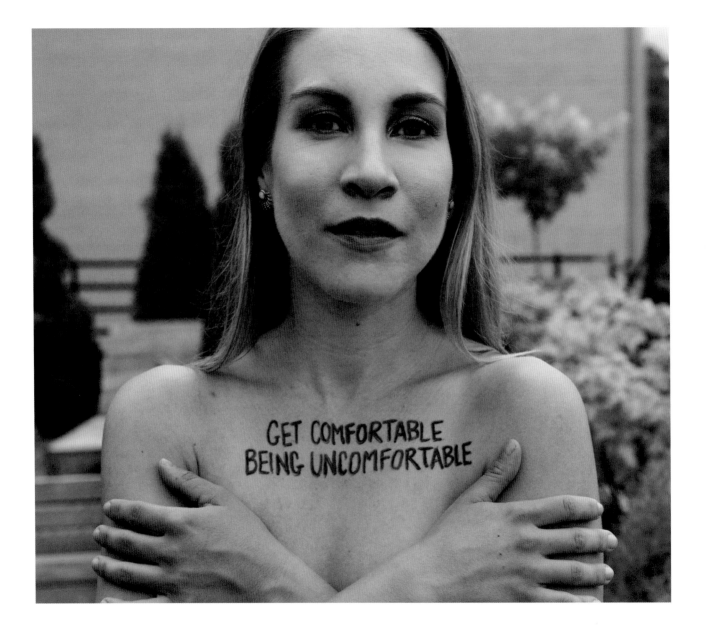

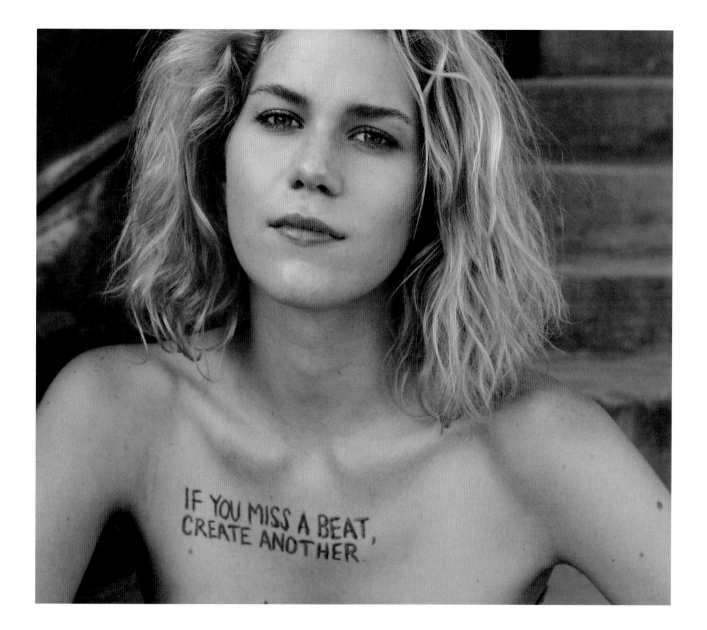

WHEN I LEARNED TO TAKE RESPONSIBILITY FOR EVERYTHING IN MY LIFE AND STOP SUCCUMBING TO THE ILLUSION OF VICTIMHOOD, IT AFFORDED ME AN OPPORTUNITY TO TRANSCEND MY OWN SELF-IMPOSED LIMITATIONS.

There is always a choice regarding the reality we buy into, and therefore energize and perpetuate. Learning to align more fully with an acceptance and appreciation for who I am gave way to a passionate love affair with myself and life's journey. Finding the courage to take back ownership over my experience without citing someone or something else as a source of pain and disappointment because they couldn't live up to my projected ideals was and continues to be an exceptionally liberating power play. Now I find myself navigating the parallels between surrendering to life's magic, getting clear about the truest longings of my heart, and trusting that those I'm meant to dance with will be magnetized by my light and not my darkness.

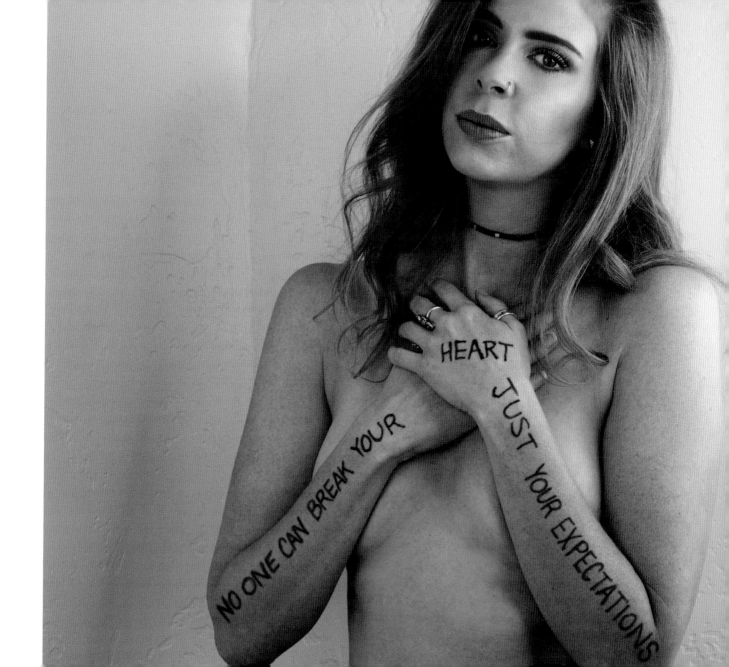

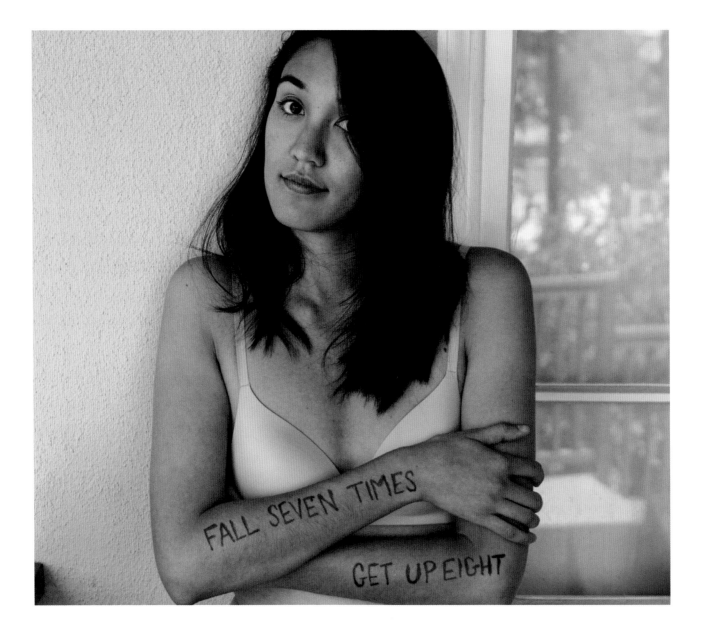

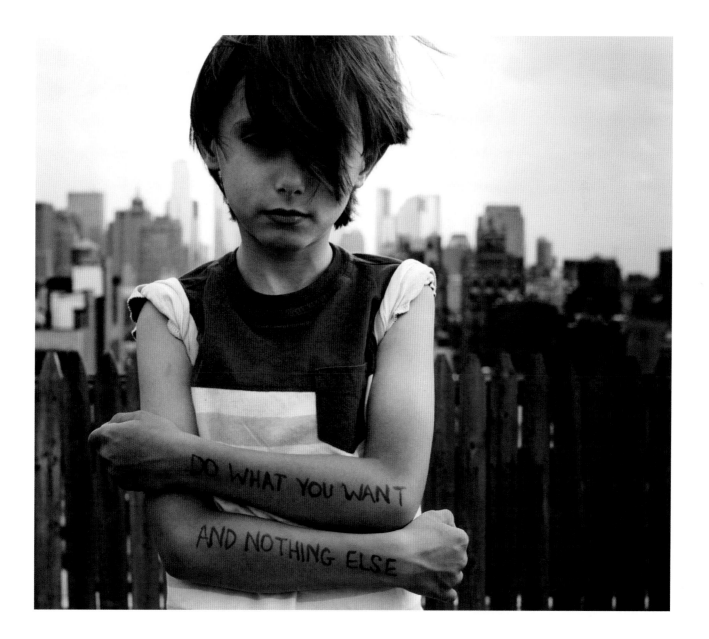

I WAS BOUNCING AROUND LOS ANGELES, PURSUING MY ACTING CAREER, AND LIVING THE GOOD LIFE FOR A LITTLE OVER A DECADE WHEN MY DAD'S CANCER RETURNED FOR THE SECOND TIME.

Even though I had just joined the Screen Actors Guild (a longtime goal of mine), and my career was finally heading in the right direction, there was no question in my mind that it was time to hit the pause button. I made the decision to move back to Pennsylvania to help my dad get better, and to be there for whatever my mom needed. I was able to spend almost another year with him before he passed away. Losing my father, my number one source of strength and protection, completely destroyed me. But just because I got knocked down doesn't mean I got knocked out. It's taken time, but now more than ever I know who I am, I know what I want, and I have a much better idea of how I'm going to get there. It's never too late to begin again. After all, every great story needs a few rewrites.

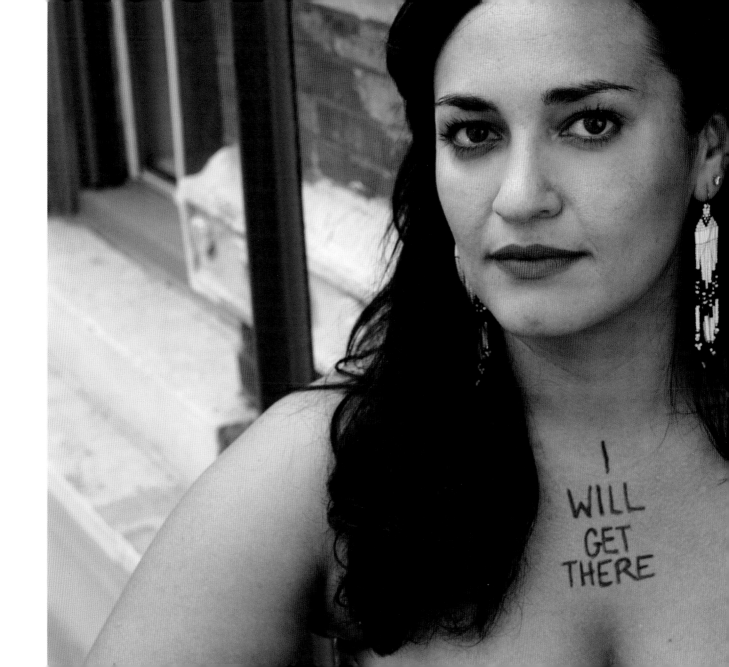

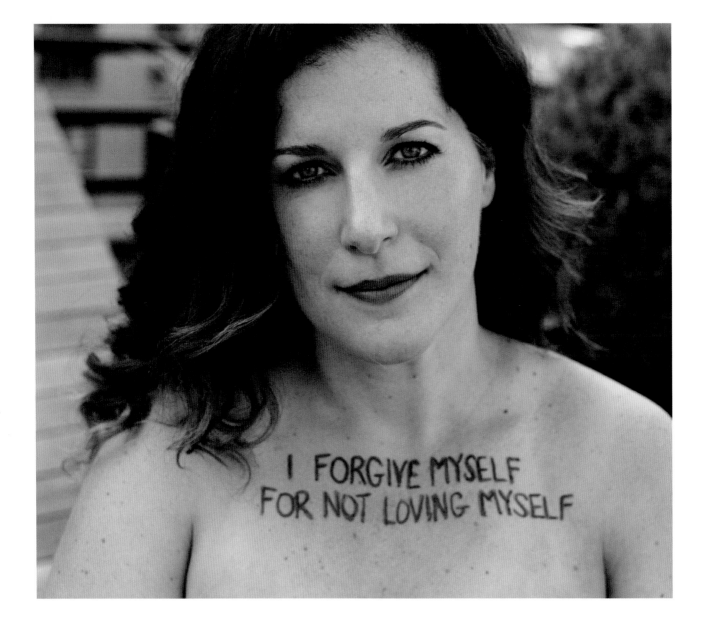

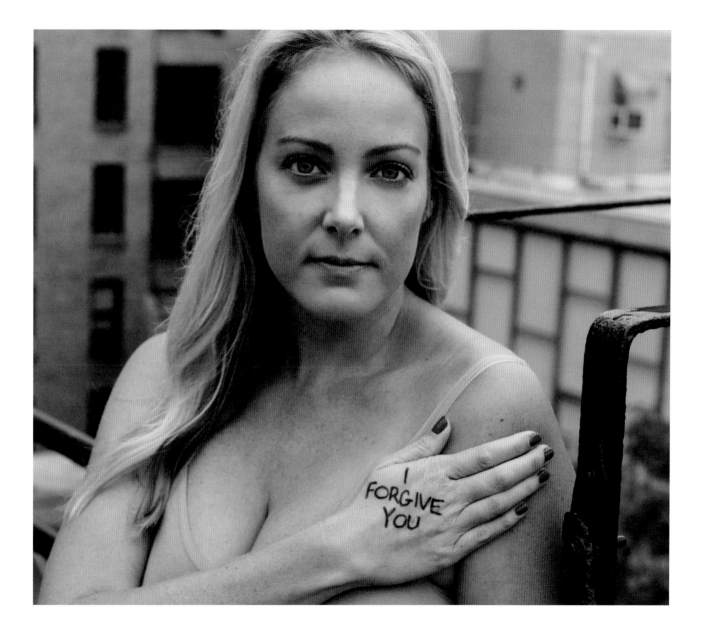

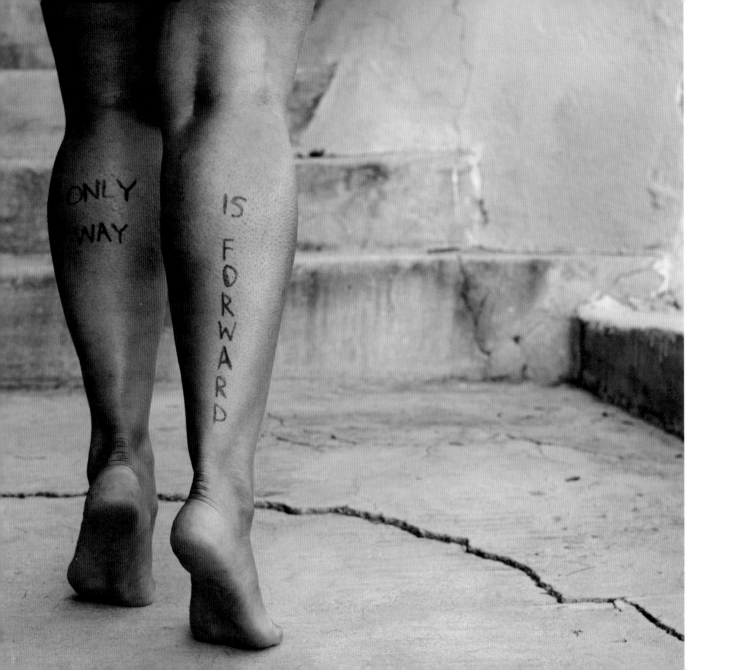

I SAT WITH THE IDEA OF QUITTING MY JOB AND STARTING A BUSINESS WITH A FRIEND FOR MONTHS.

Could I really make the move forward? Leave my safety net and take a chance? I was anxious, scared, and even sad. I tried to make peace with perhaps doing both, my job and my business. I had a master plan, and then the universe had a different plan for me. So I left . . . and moved forward.

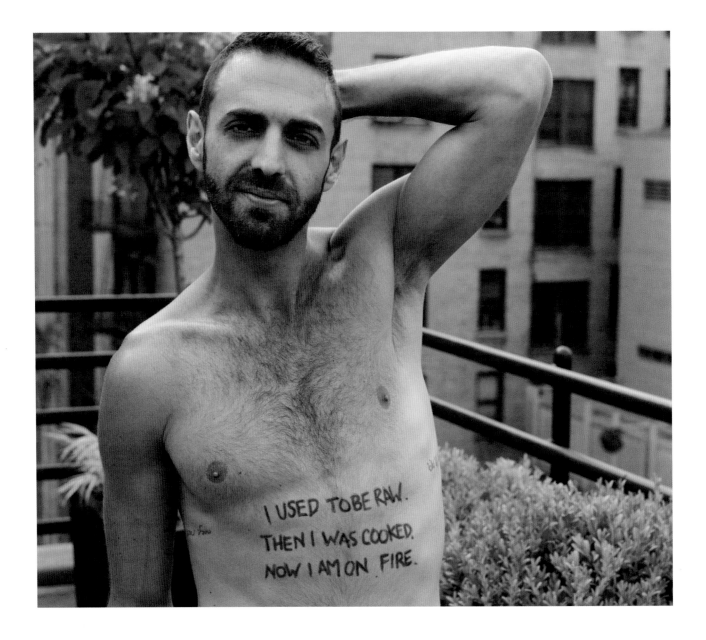

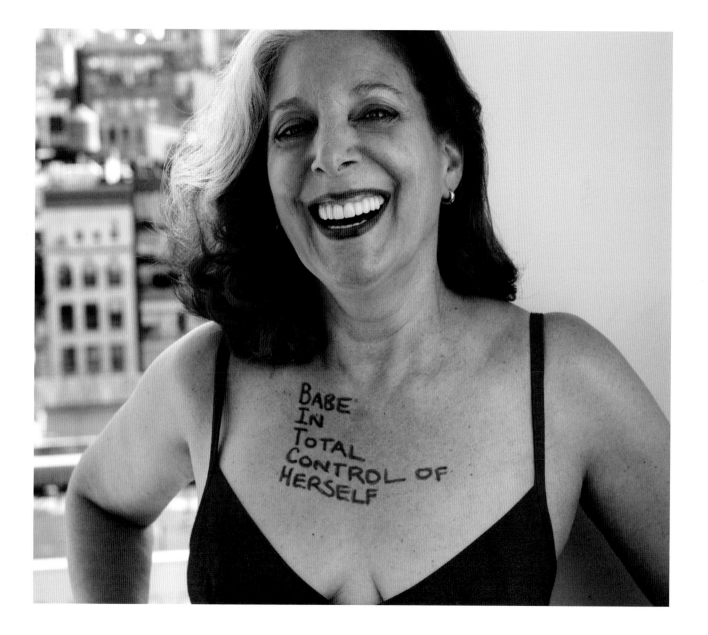

MY STORY COULD BE YOUR STORY.

It could be your sister's, your best friend's, or even your mom's. I've made choices in my past that have made me sad. I've made choices in my past that have left me empty. I've made choices in my past that have left me feeling weak. But here is the thing: they were *my choices*, and that makes all the difference.

I live with no regrets and no sorrow, for I know that I've had full control of my body. I've had full control of my life. I am a mother. I am a wife. I am happy. I am strong. My heart is full.

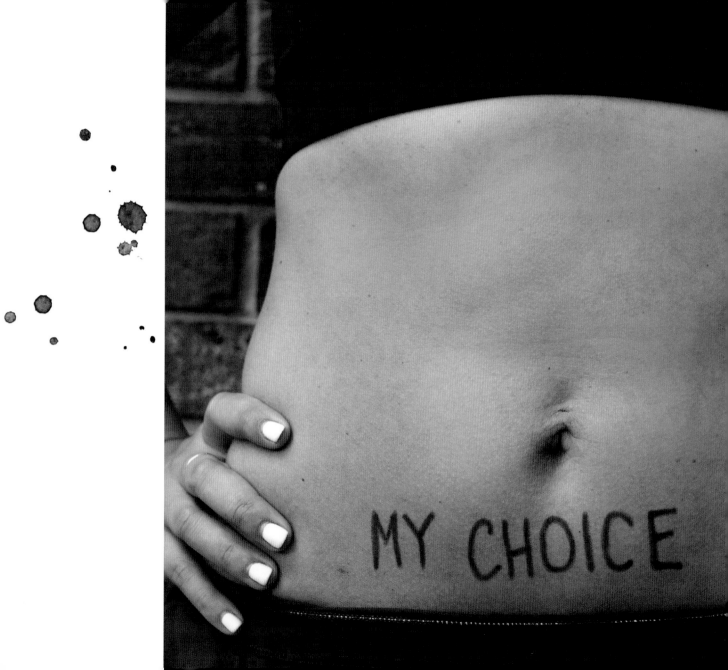

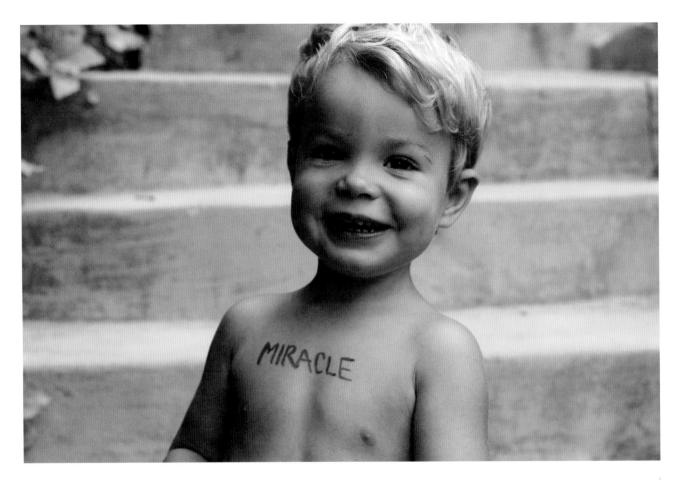

After two miscarriages, one stillbirth, twenty-four months of "trying," twenty negative pregnancy tests, three rounds of failed IVF, and one hundred fertility injections, I was told by a doctor that I'd never have a biological child. I became pregnant with our second miracle the day we were matched with our daughter. People who have heard our family's story love to tell us "that happens all the time," but we have yet to meet anyone else who has shared a similar journey. Throughout life, I think we all search for those "me-too" stories that connect us to each other in some way. This is my family's story.

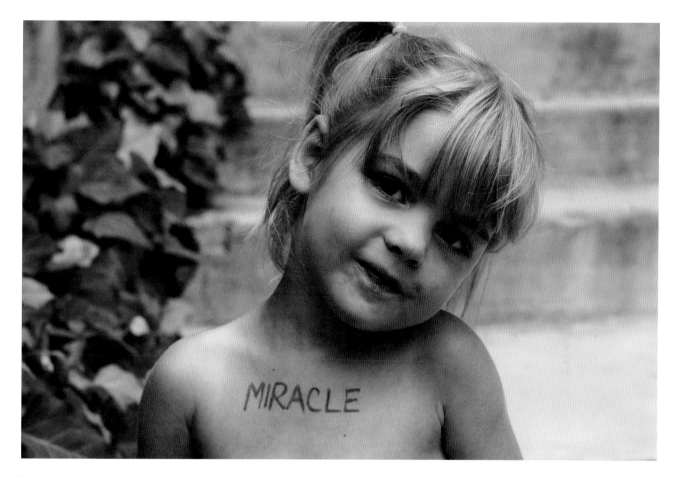

I am the mother of non-twin two-year-olds, and their story is impossible to tell separately. They were born six and a half months apart. I am reminded of a quote by Albert Einstein. "There are only two ways to live your life: as though nothing is a miracle, or as though everything is a miracle." While most adoptions take years, we were matched with our daughter's birth parents in the record time of just two weeks. Our first miracle was born three months later. Today, she has both biological and adoptive family across the country who love her and play an active role in her life.

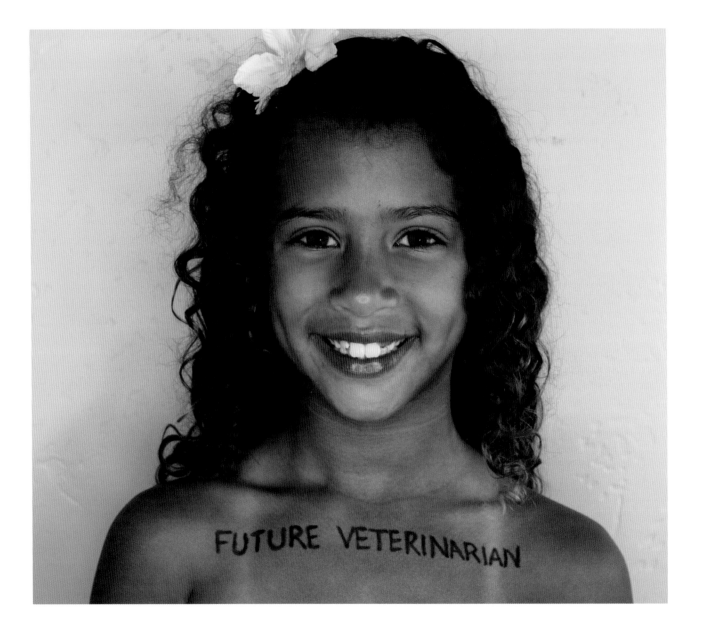

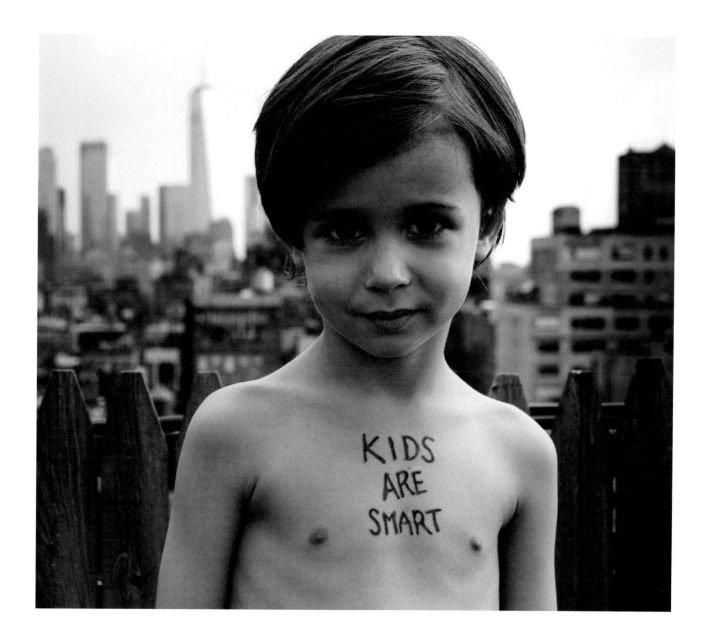

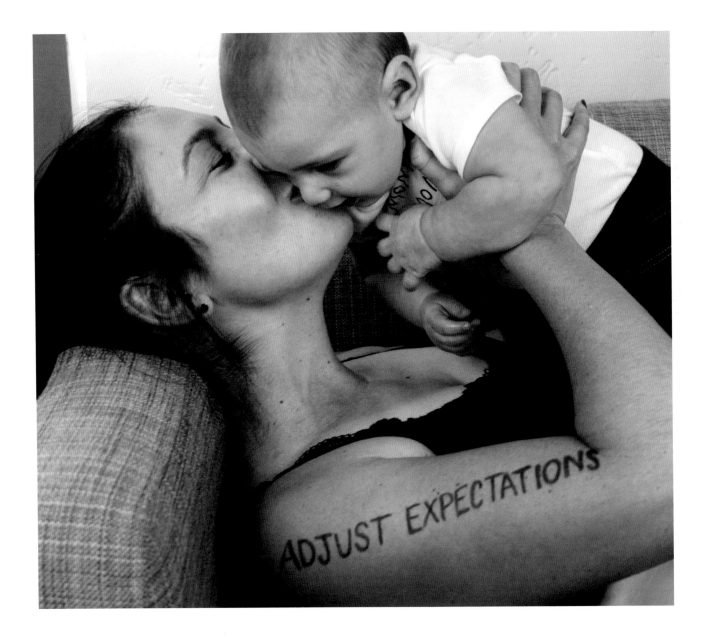

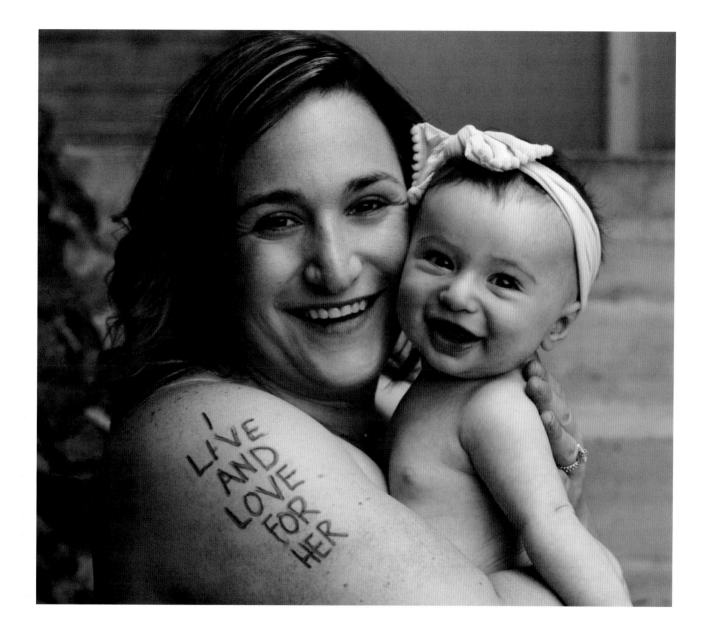

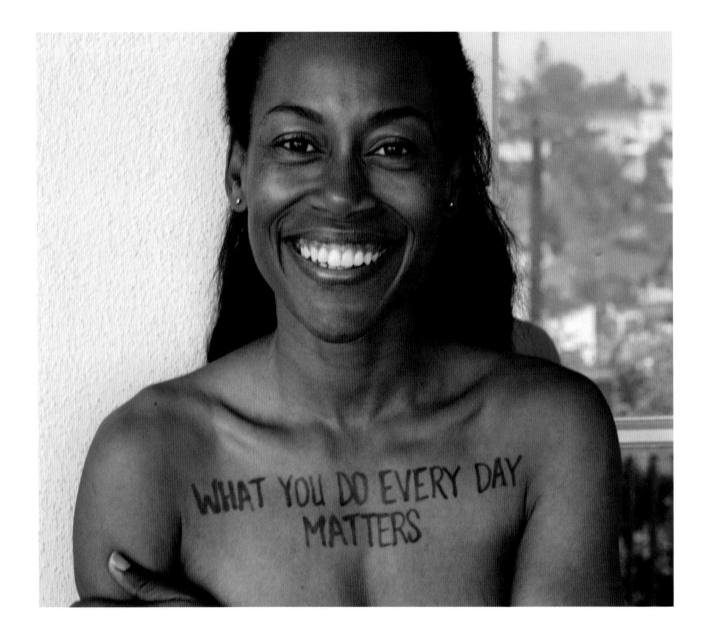

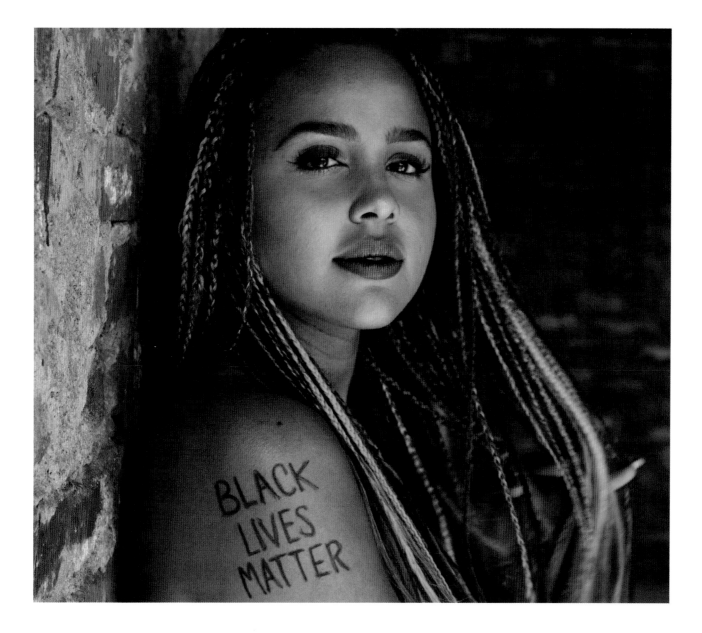

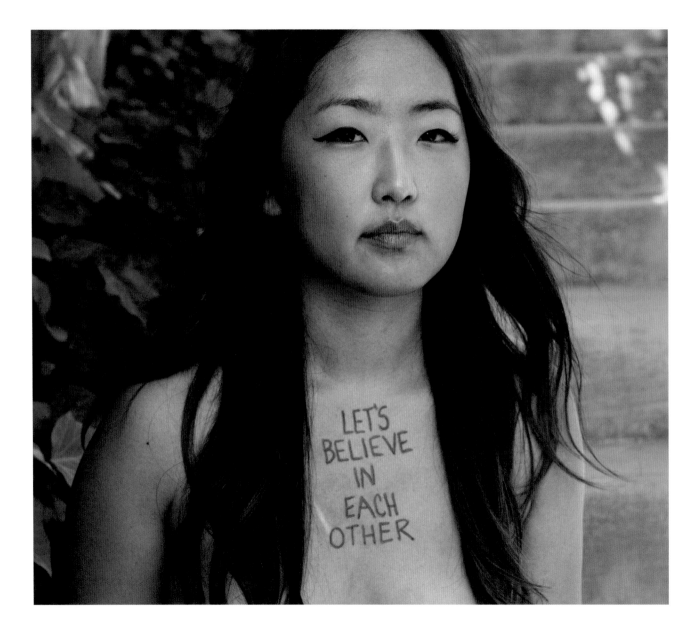

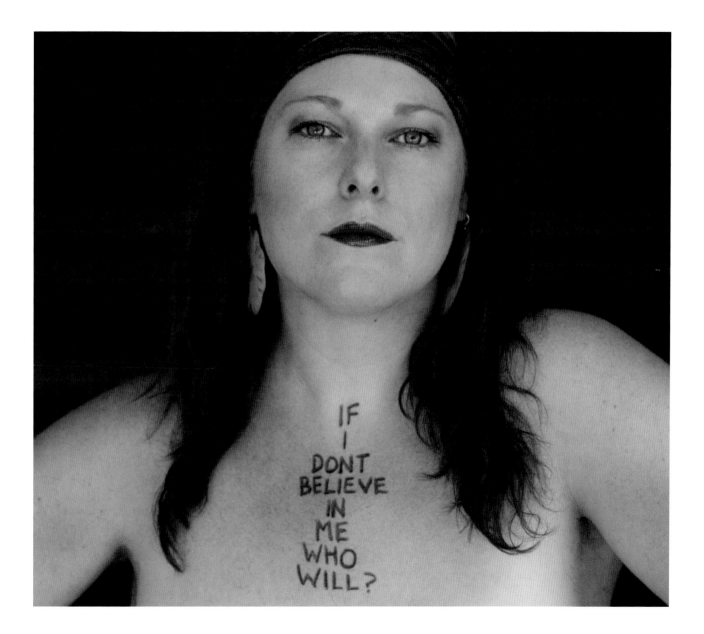

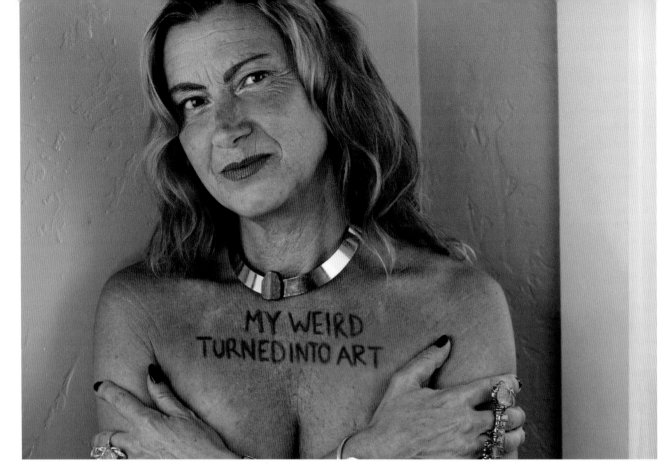

All through my life, I have had the sensation of just kind of floating through while never feeling completely happy or satisfied. I was a good student and then went through a variety of occupations. The most excited and fulfilled I felt was when I was creating, writing, singing, painting abstracts, and making strange sculptures. So after my last "legit" job (as a retail store manager and buyer) ended, I had to make a change. I did not want to have another boss; I wanted to be my own boss! When I started to create jewelry, it sort of all clicked. I married my love for fashion with my talent for making things with my hands. I finally felt truly happy. I remember the first time I heard a client say, "Wow! I love your pieces. They are so unique; it's like art!" and I thought, *Yay! My "weird" turned into art.*

A great idea is rarely fully formed from the beginning. That's why the creative process is onerous. It shouldn't be rushed due to insecurity or anxiety. It's supposed to suck. Relax bruh . . . Because one day it will be finished. And everybody will know that you know what the word "onerous" means.

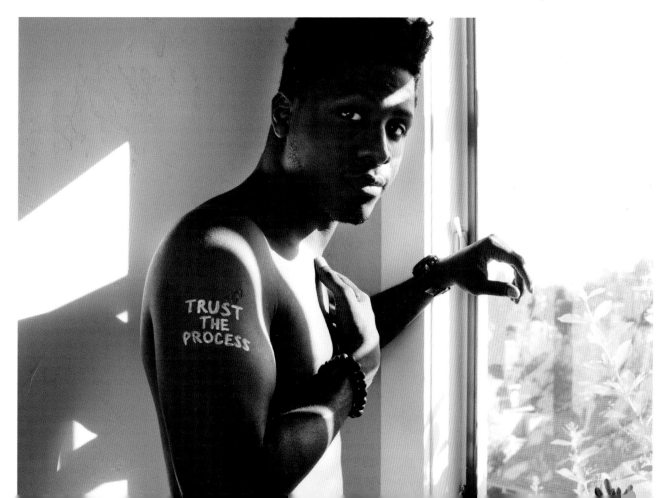

ONE OF MY CLOSEST MENTORS, RICHARD HESS, ONCE SAID, "MEASURE YOUR CAREER WITH A COMPASS, NOT A STOPWATCH."

I didn't take all of my education as seriously—maybe I should have—but I took that to heart. As the years rolled on, I had many ups and downs, but I kept that ideal at the center of my personal mantra, and it evolved into something more. The concept of applying continuous pressure to a problem, a career, an opponent, even a mountain. What on this earth steadily wears away at even the most resilient bedrock? What chips and flakes at the very foundation of continents? Only the Tenacious Tide, and it is the concept, the power that I draw from in my darkest hour—steady, continuous, unyielding, and uncompromising.

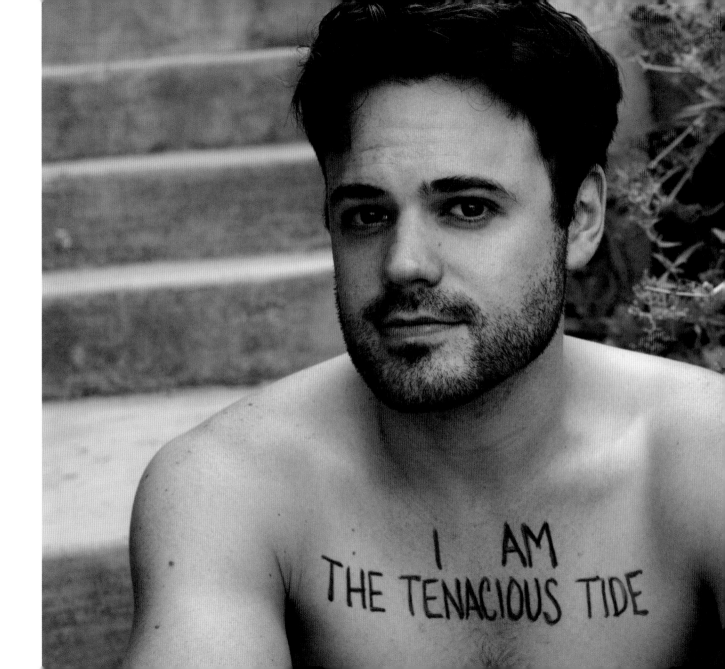

KNOWING THAT MUSIC AND THEATRE ARE IN MY BONES IS COMFORTING TO ME.

It allows me to make mistakes and take opportunities that might have not been accessible to me had I not done the simple act of saying yes. It's the feeling of knowing that you helped change the course; helped shape an art form so rich in its history of innovators that you can and will be remembered. When I see or hear what's in my head be accomplished and it is perfect, the amount of joy I get is immense and just as fulfilling as if I were the one in the lights or in front of the mic. Finding and telling the truth in music is truly a gift and one that I love to share. I can't label myself as anything but a storyteller, and trying to make my art fit into a category has been a constant struggle of asking who I am and what is going to define me. There is no finish line, you never stop learning; intuition and wit help you truly express your complete understanding of the human condition, but you must live your life knowing that you are following the call that stems from your core of expression.

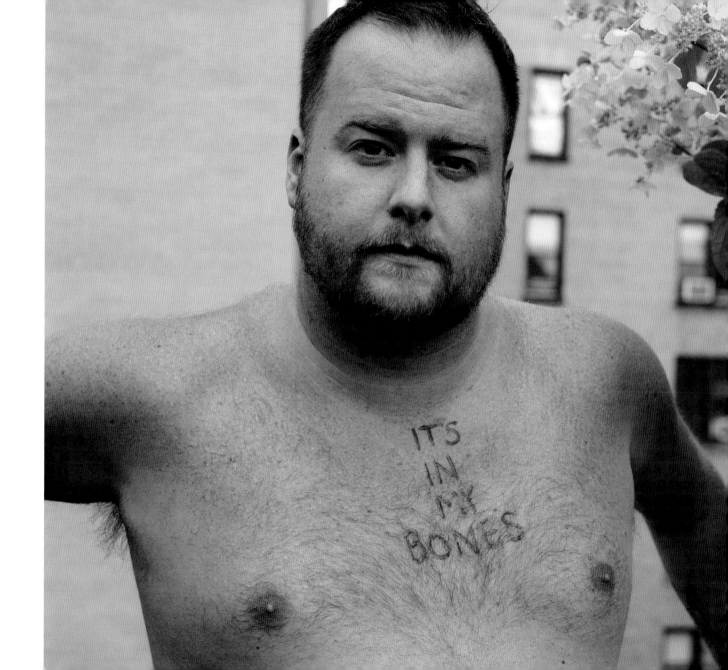

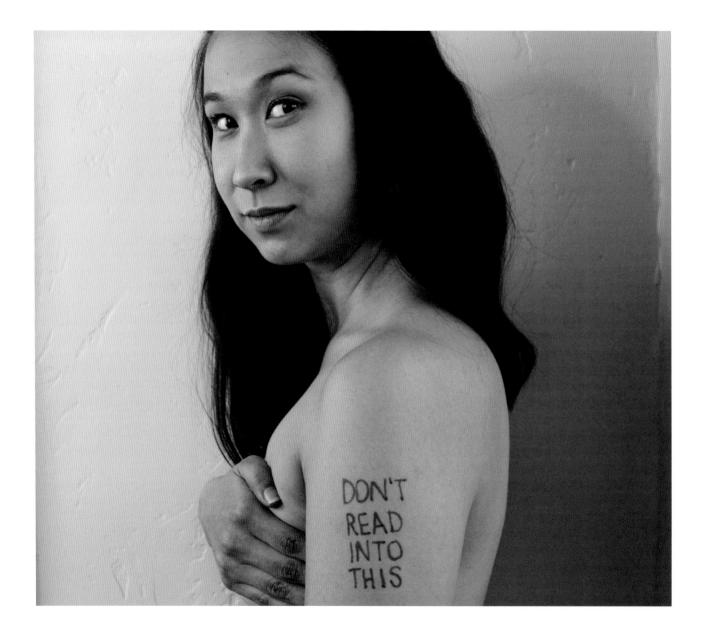

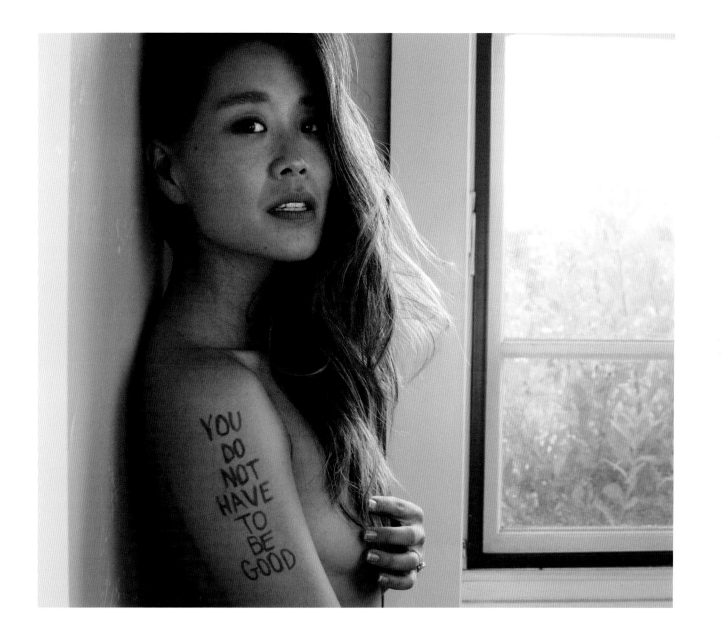

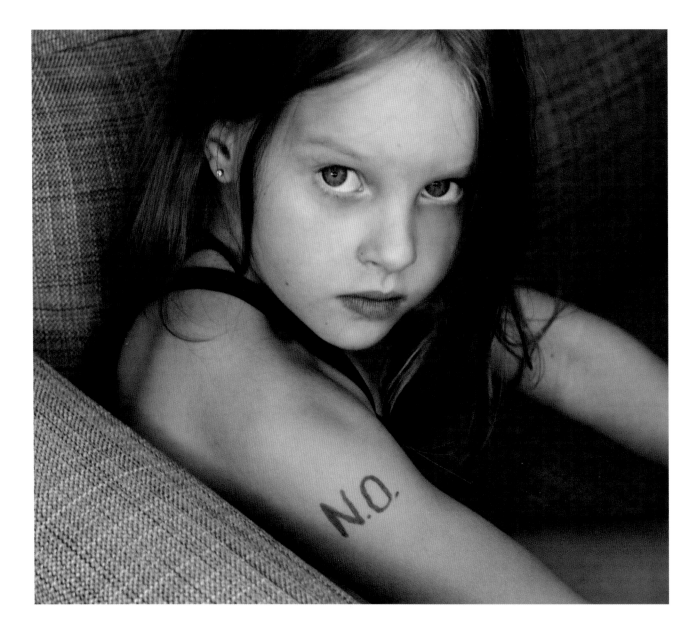

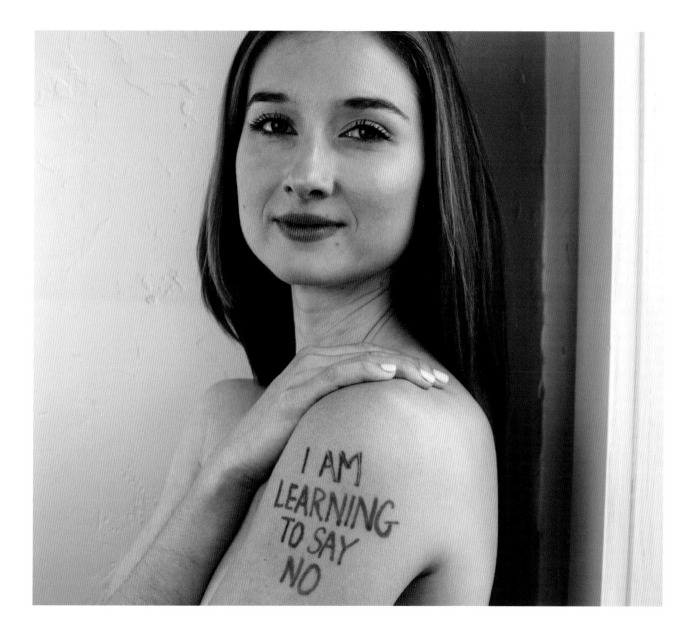

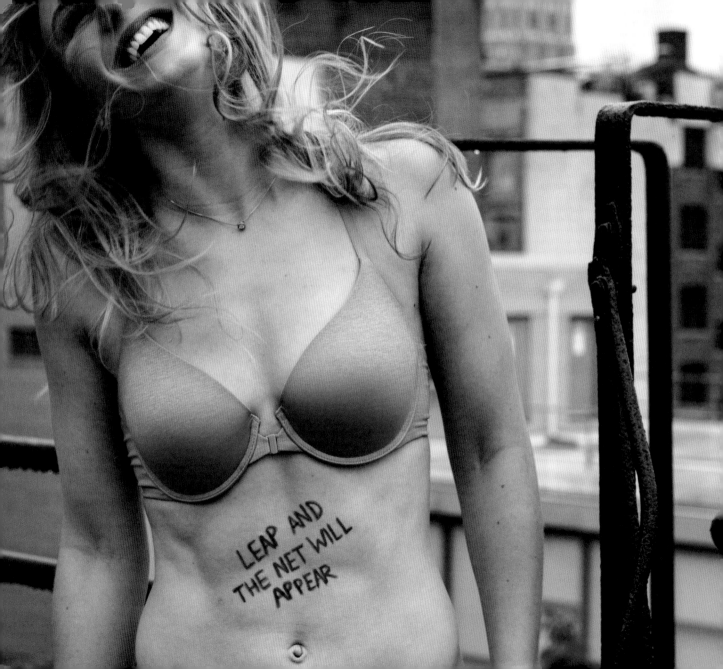

I SPENT MY FIRST THREE YEARS OUT OF COLLEGE ON THE ROAD, TOURING.

At first it was thrilling to be traveling so much and working on amazing pieces of theater. Eventually, after countless cities and hotel rooms, I started to grow restless. I was hungry for my Broadway debut and to be settled in one place. I really wrestled with what to do. Do I leave a consistent paycheck and what had grown into a comfortable situation? Do I take a risk? One day it hit me—I needed to go to New York if I wanted to be in New York. It seems so obvious now . . . So, I took a leap of faith. I quit my touring job and moved to New York City. I got myself a postage stamp–sized apartment (with no TV) and went to work creating a life for myself, taking classes, connecting with friends, and auditioning. Within six months I booked a job to be in the original company of an original Broadway show. I know it sounds cliché, but "Leap and the net will appear" really was my mantra during that time. It's not about throwing yourself recklessly at something you think you want; it's about answering an inspired calling. If you do that, the universe will support you.

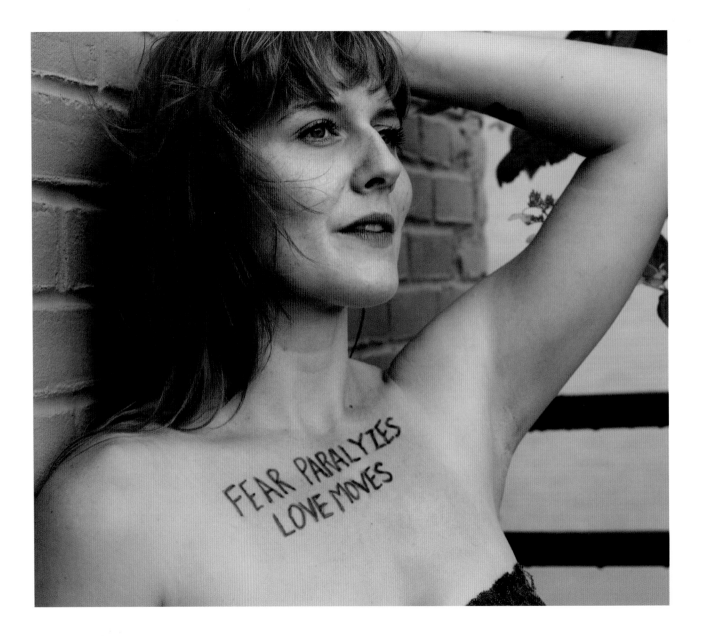

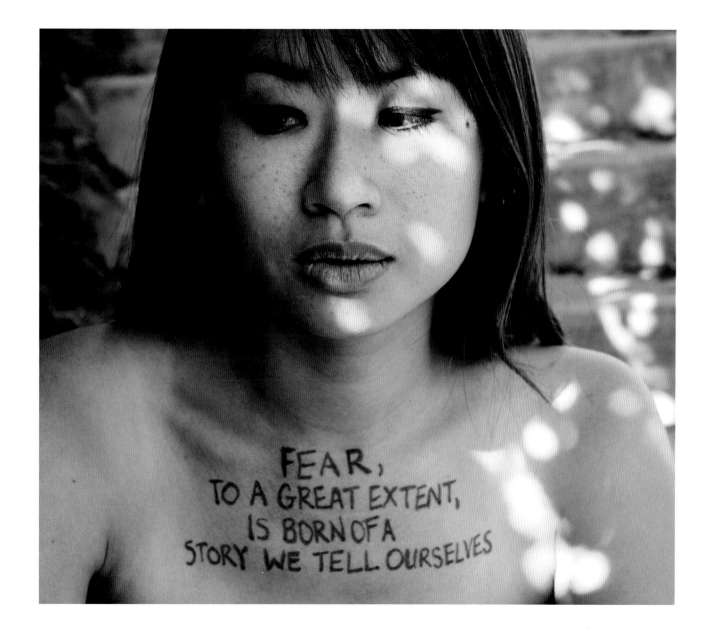

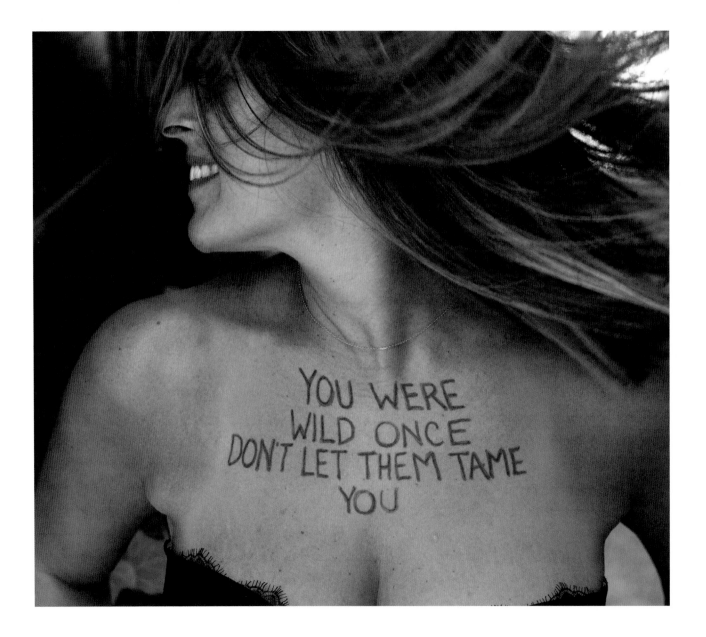

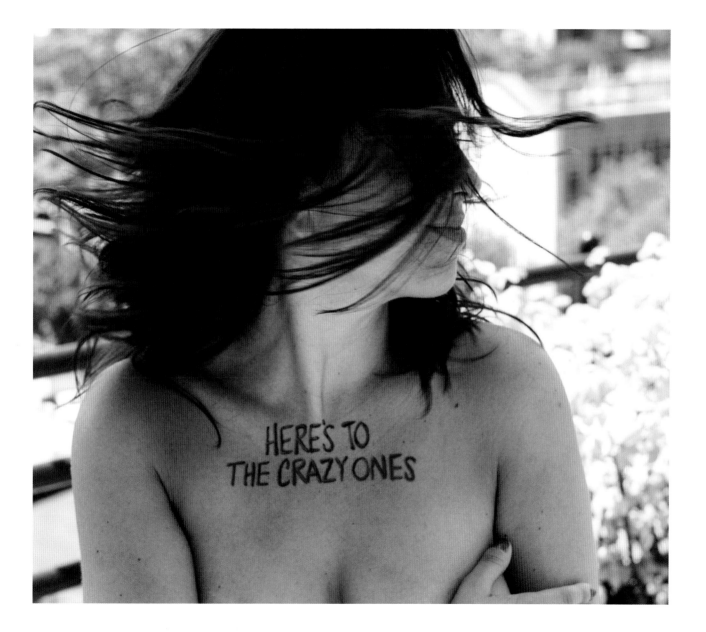

HOW MANY TIMES HAVE WE NOTICED OURSELVES APOLOGIZING FOR NO GOOD REASON?

We often throw unnecessary apologies into our daily interactions to avoid conflict, discomfort, or to avoid standing out and being different. For whatever the reason, each unwarranted "I'm sorry" slowly starts to chip away at our self-worth. We begin to feel small. And little by little we lose sight of our power and our innate, unique qualities we were born to share. So stop apologizing and start stepping into your bigness. Because beneath all the "I'm sorrys" lies your beautiful, raw, and naked truth that's waiting to be unleashed.

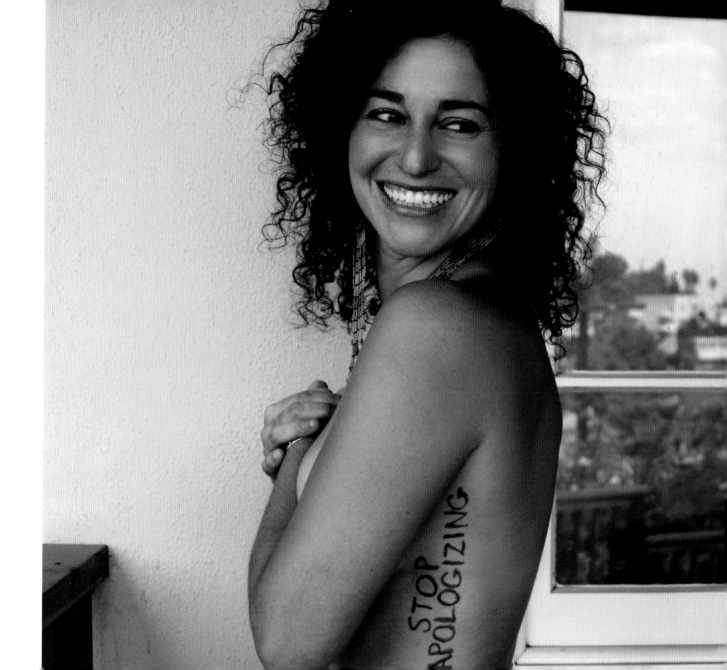

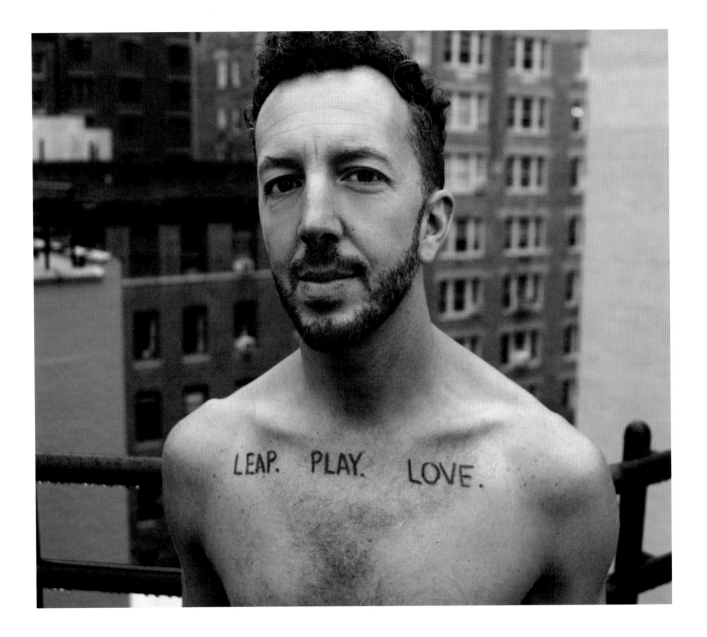

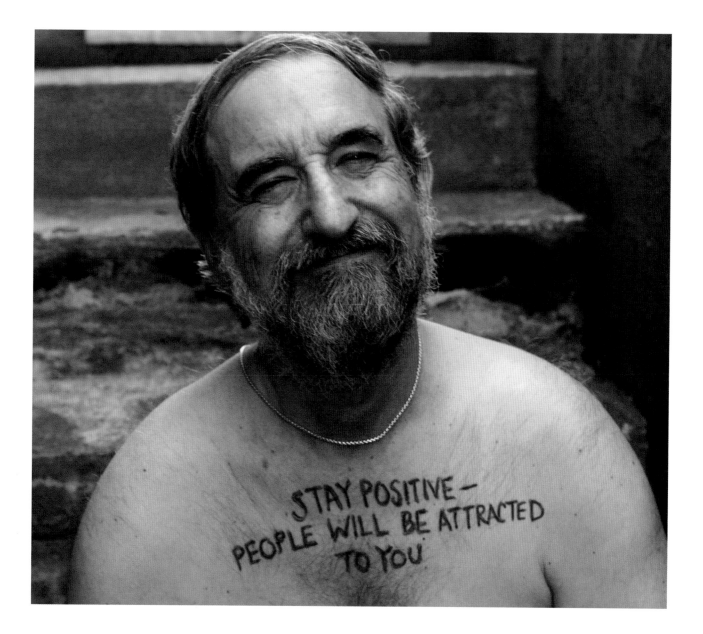

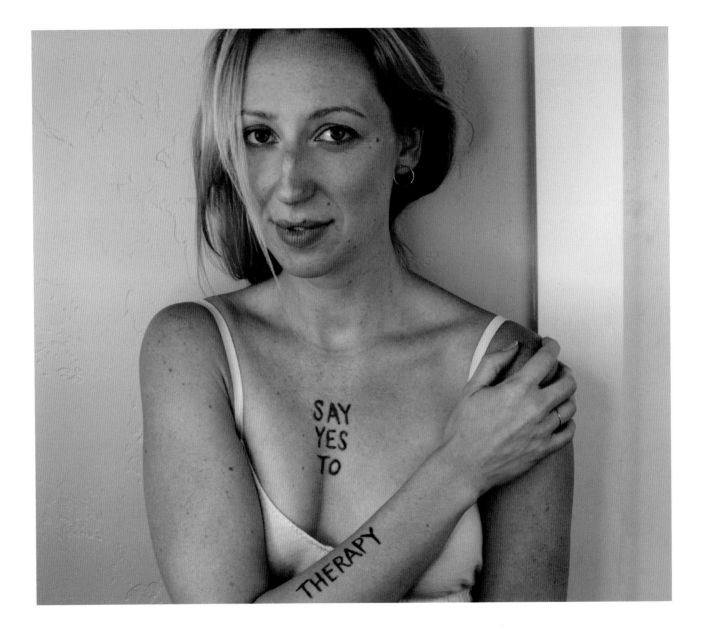

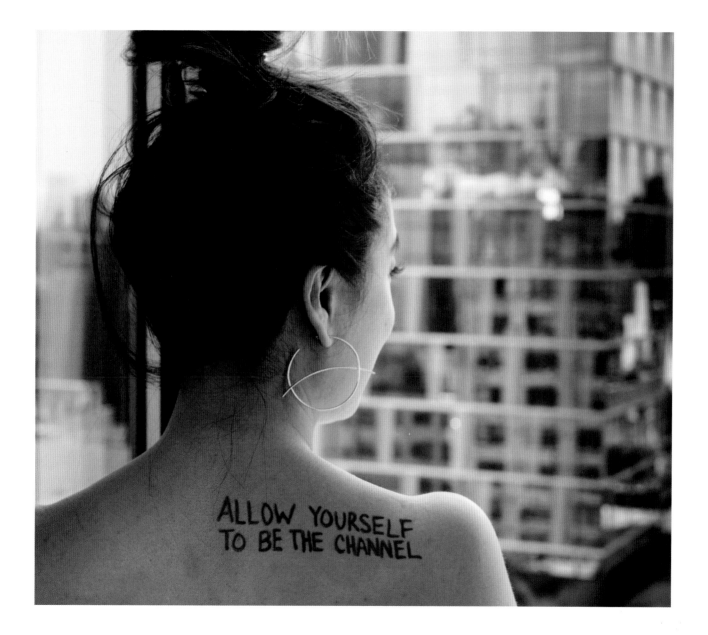

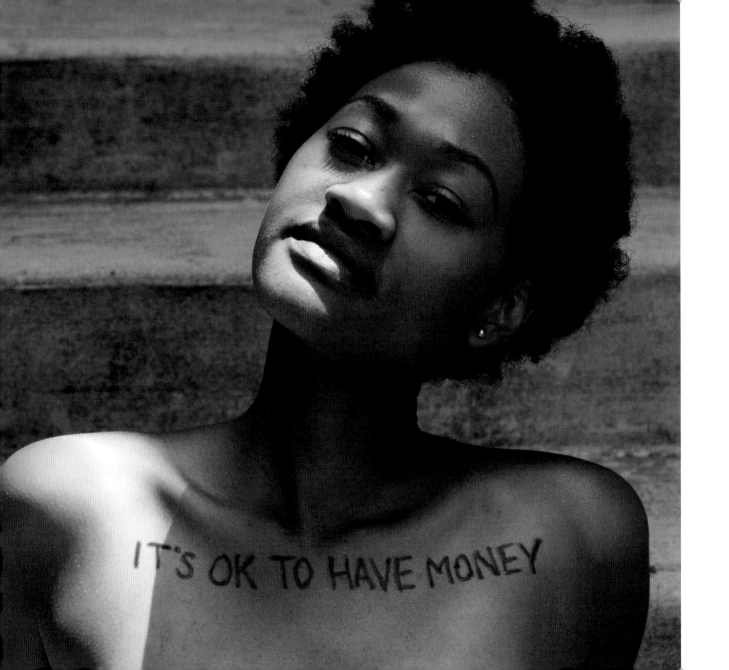

AFTER YEARS OF LIVING ON MY OWN AND LEARNING HOW TO MANAGE MY MONEY, I REALIZED THAT I COULDN'T KEEP IT.

I would always find a "good deal" to spend it on and I had a difficult time saving. Subconsciously, I felt it wasn't honorable to want money, let alone have it. Then one day it dawned on me that this behavior deprived me of the quality of life I desired. I had to learn that (1) It's okay to have money, (2) I don't have to spend it just because I have it, and (3) Abundance would allow me to spend it on more than just essential items. I'm continuing to work through this, but I know that I'm a good person when I save and when I buy nice things.

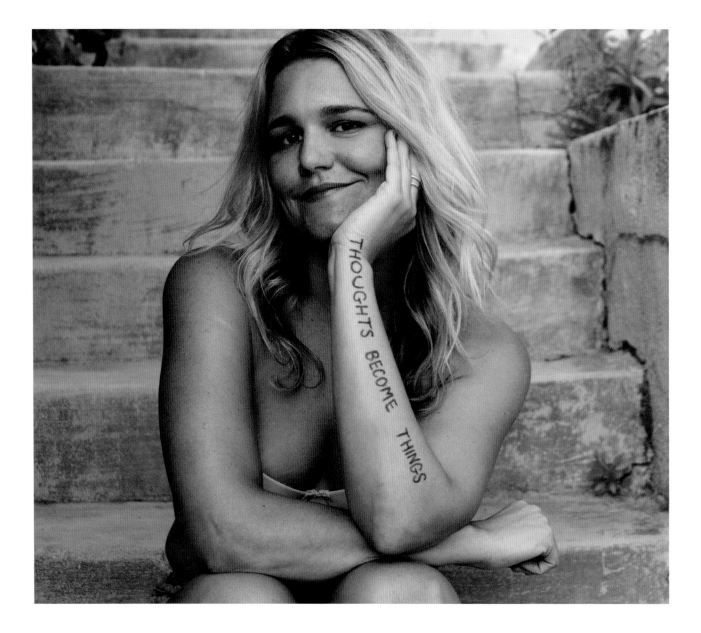

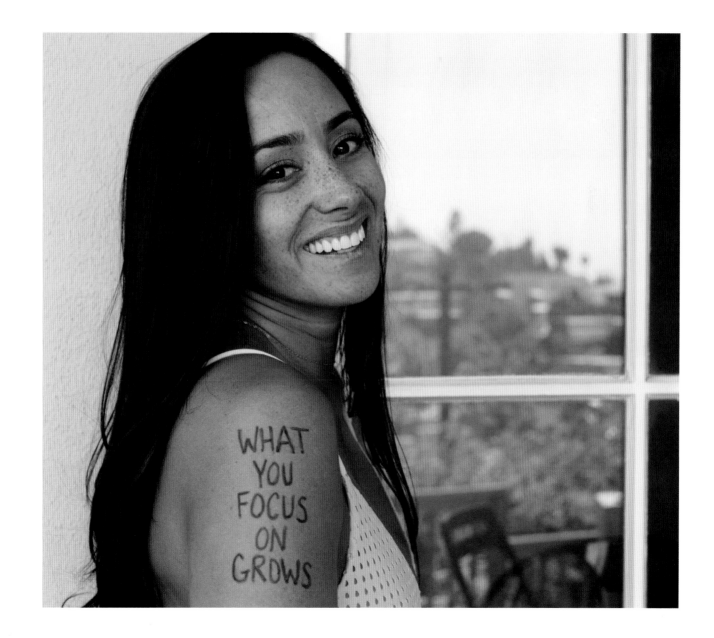

THERE IS A JAPANESE ART OF FIXING POTTERY BY FILLING THE CRACKS WITH GOLD.

I feel like that's what I'm doing with my life. About three years ago, I was diagnosed with PTSD. Finally, after years of struggling and suffering on my own, this thing I was experiencing finally had a name. I now visit a trauma therapist once or twice a week as part of my recovery, to sort through my pieces. Yes, I still have very hard days, but I am strong and beautiful, despite the cracks. I am Golden.

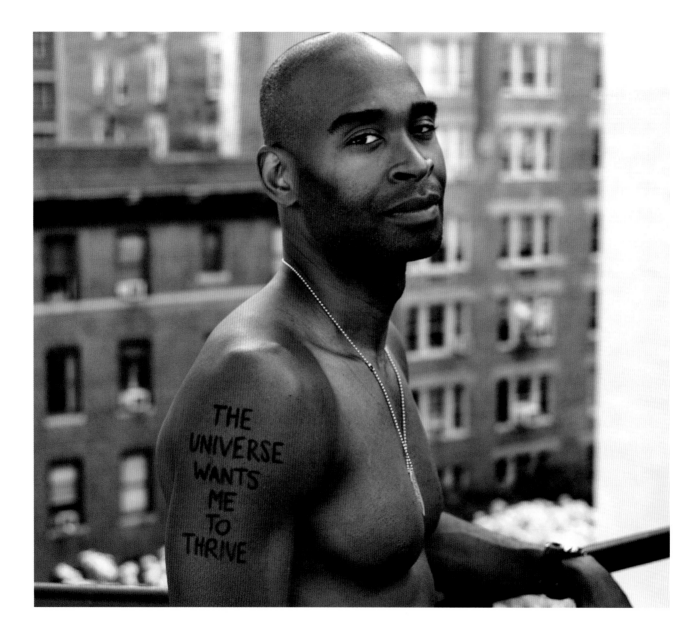

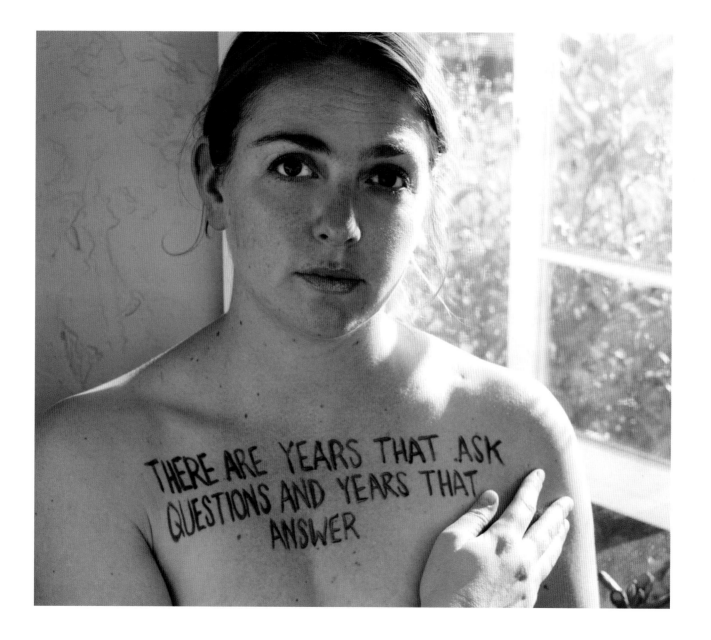

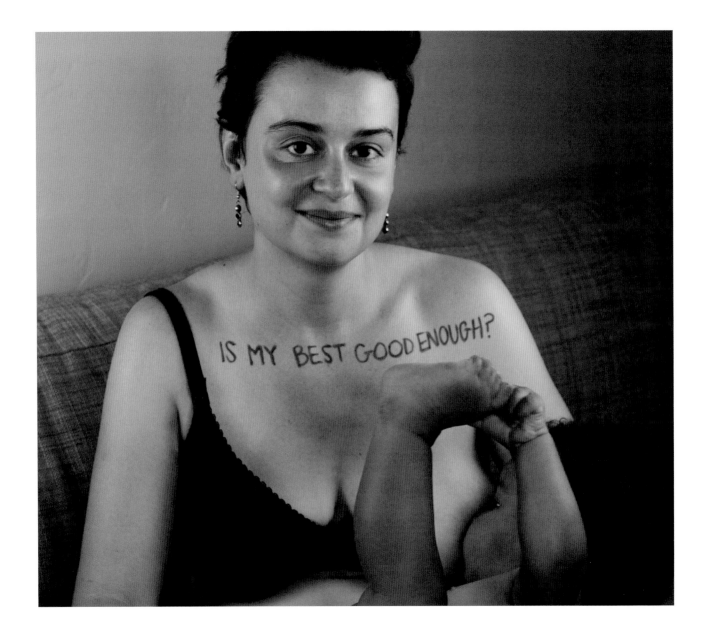

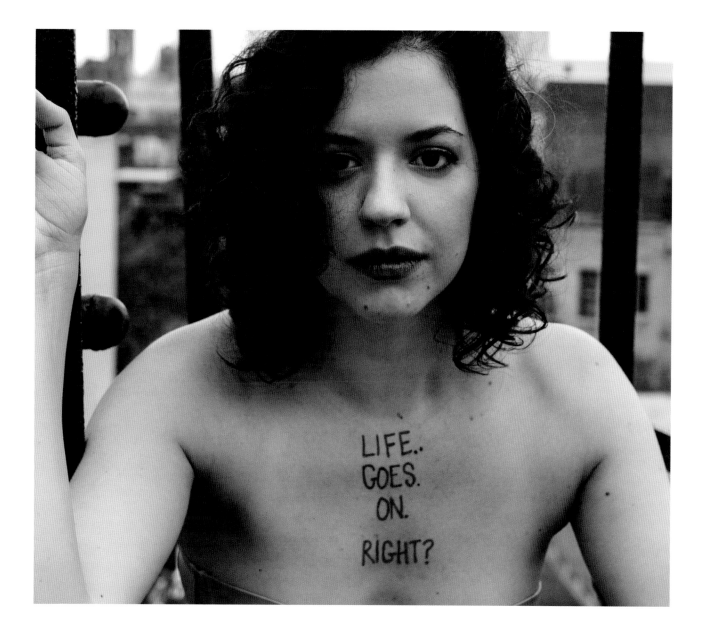

ON OCTOBER 24, 2014, AT THE AGE OF TWENTY-ONE, I QUICKLY SAW THE WORLD THROUGH A DIFFERENT LENS WHEN I RECEIVED A CALL THAT MY FATHER HAD PASSED AWAY IN A FIRE.

Concerns shifted from midterms and college parties to catching the next flight from school to family. As the oldest of a single parent, I felt the walls of responsibility creeping in. It seemed my reality quickly became something that stories are made of. I returned to school, though my mind was on other things: the difference between selfishness and self-love; discovering my greatest purpose; the benefits of working to live rather than living to work; and material items versus quality moments. My broken heart caused me to lose myself until I became so numb that I had no choice but to find my authentic self. I mapped out who and what I wanted to become, and I shaped my life as if limitations didn't exist. I surrounded myself with people who spoke of love and saw potential. I voiced my needs more often and listened to others with ears of empathy. My greatest struggle quickly became my best asset. I began living the life I was meant to live.

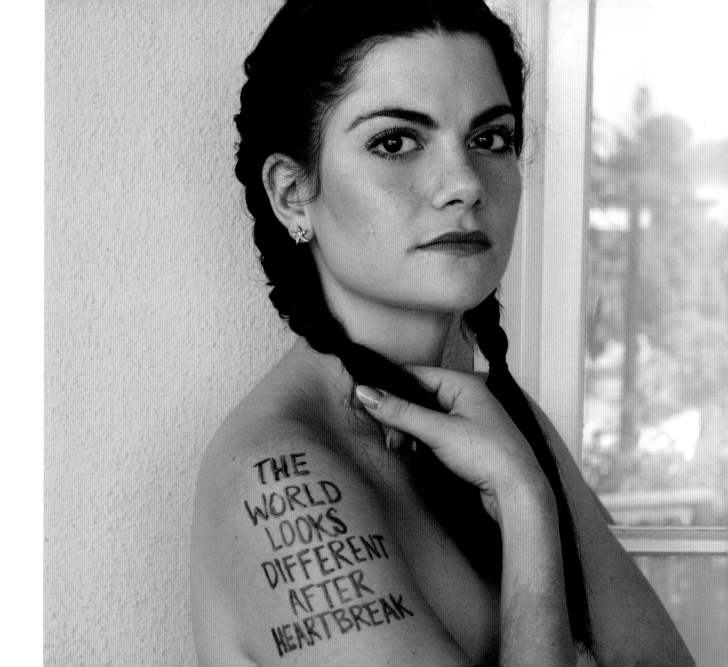

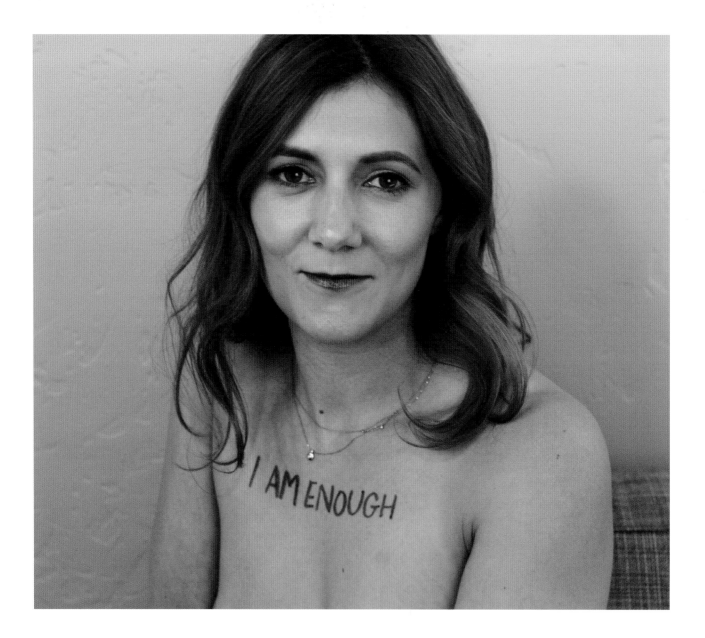

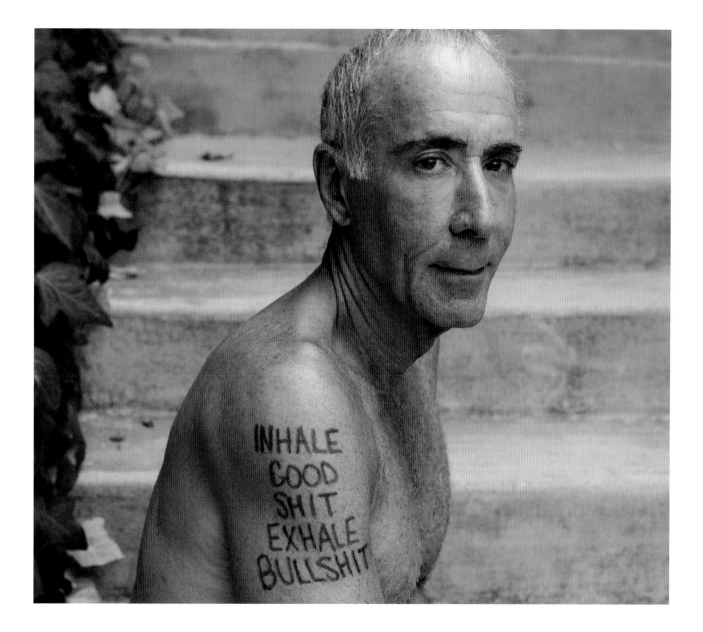

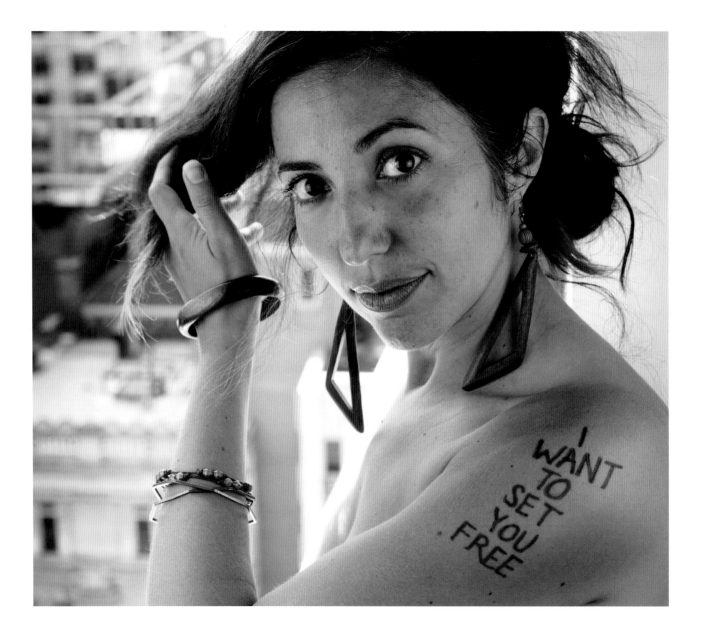

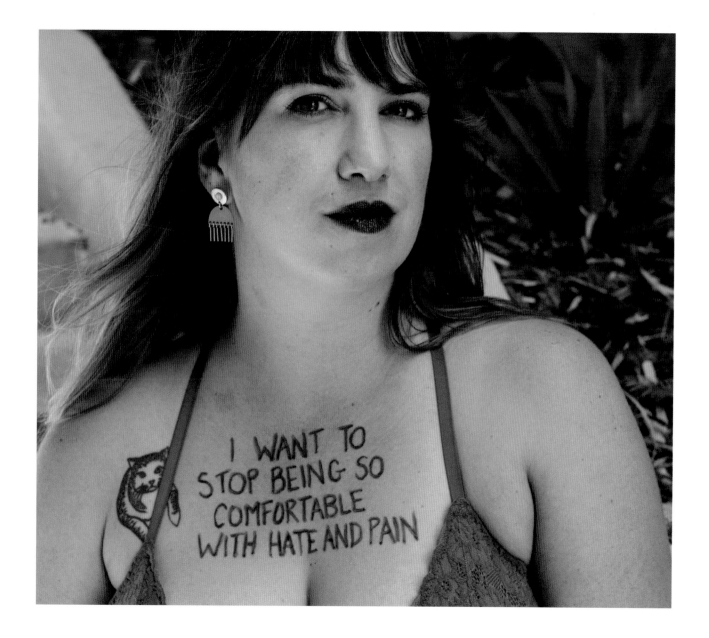

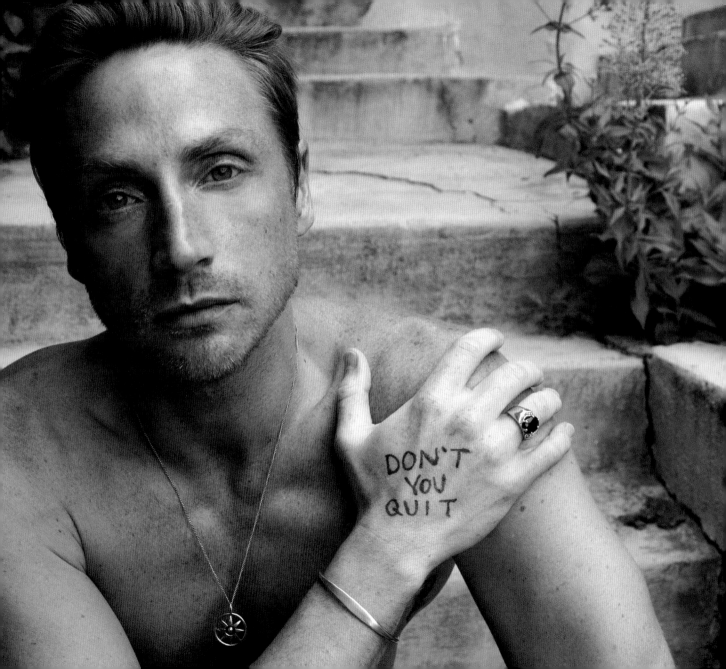

MY ENTIRE LIFE I HAVE STRUGGLED WITH CONFIDENCE.

It has been a battle since I was a child learning to swim across the pool into my mother's arms. I have feared failure and so, shied away from trying to achieve my biggest dreams, aiming instead at things that I deemed more "achievable." It wasn't until I received some sage wisdom from my father, just before his passing, that my perspective changed. I need no one's approval, and thus, need no one else's belief in me. It's up to me to achieve my dreams, and it is only with persistence that I will be able to do so. I will not quit, and you shouldn't either.

I'M AT A POINT IN MY LIFE WHERE I FEEL MYSELF CALMING DOWN—MENTALLY, PHYSICALLY, SPIRITUALLY.

I spent a great deal of my earlier years fighting, chasing, running, hating. Now, I've realized that everything is here. It is all here. Everything I've ever wanted is within myself. Everything I've ever yearned for is at arm's reach. I can slow down. Take a look around. Breathe.

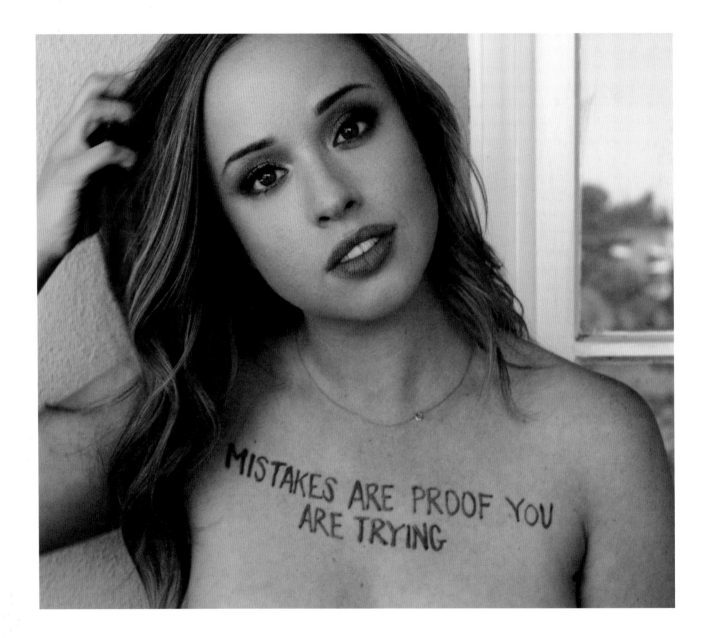

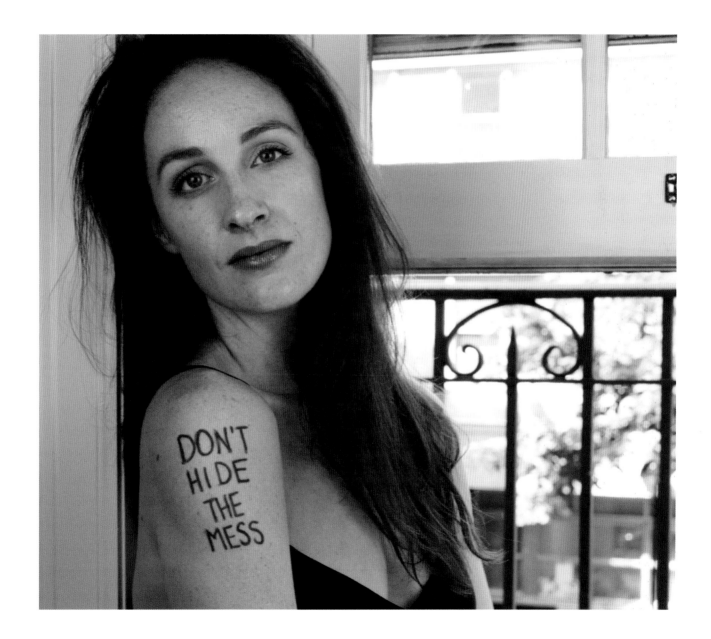

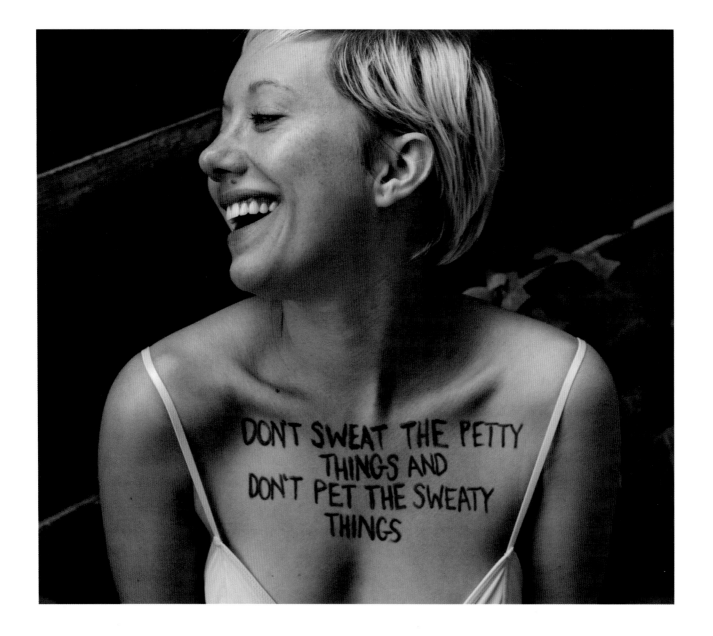

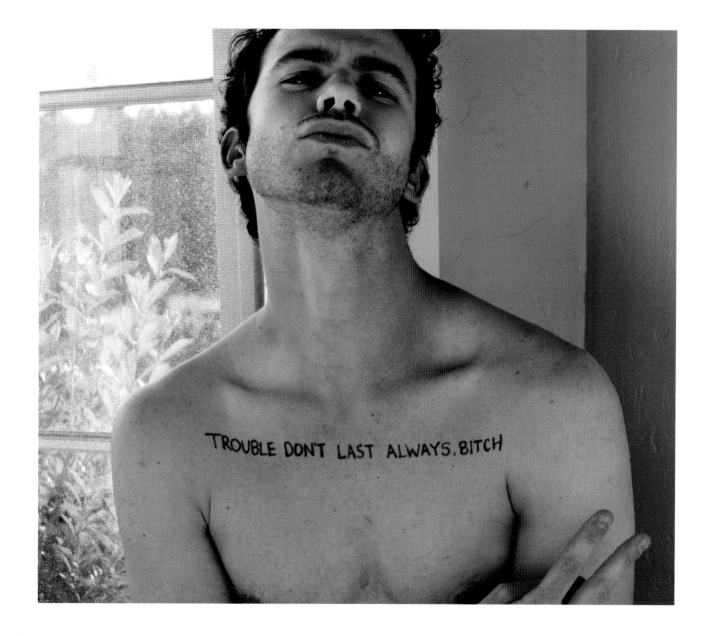

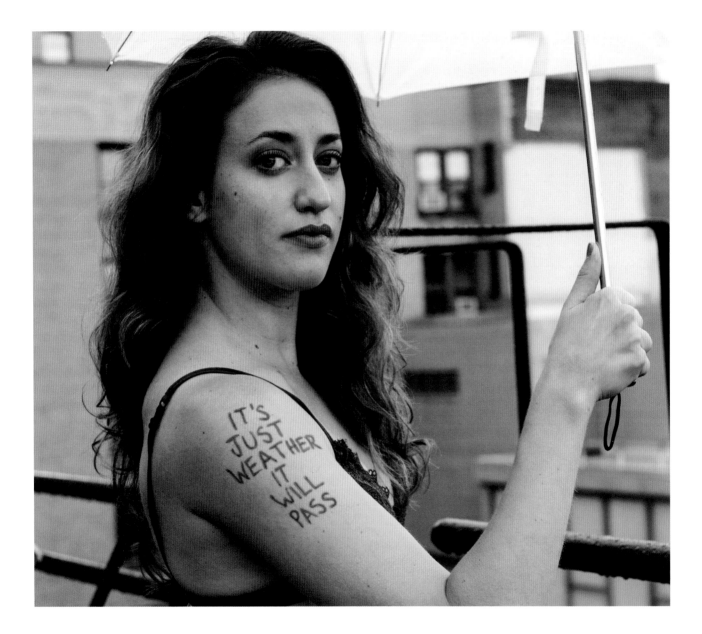

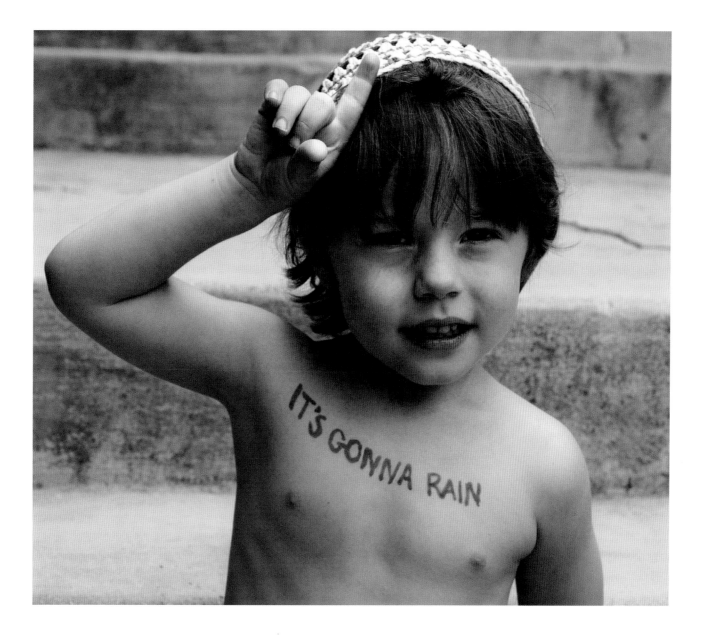

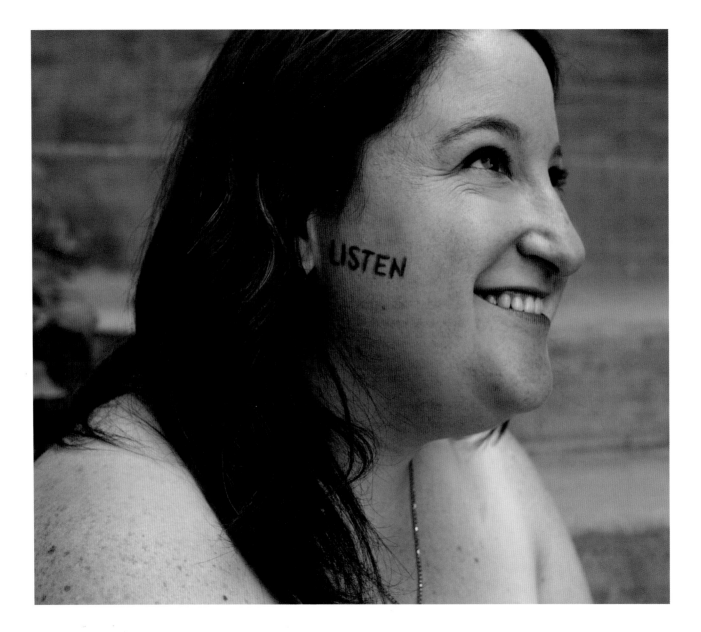

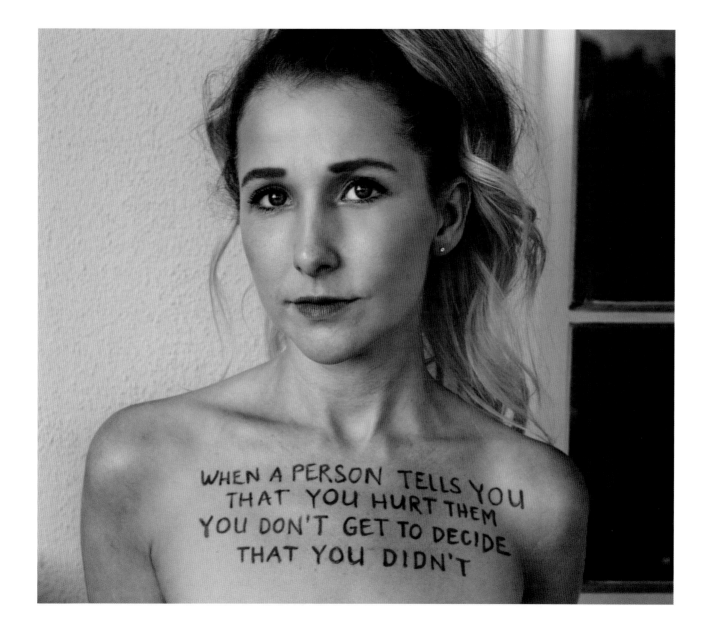

MY HEART BROKE.

I cried. I stopped. I sat in the destruction. I wore my body like a shield. I hurt myself. I identified as the destruction. I wept. I watched nations crumble. I sat stoic. Days got better. I found sacred texts. I found unsacred texts. I redefined sacred texts. Some temples abandoned me. I abandoned some temples. I climbed. I fell. I hurt. I stopped trying. I'm learning to practice. Some days I am sad, but I am more me than I have ever been before.

My heart broke open.

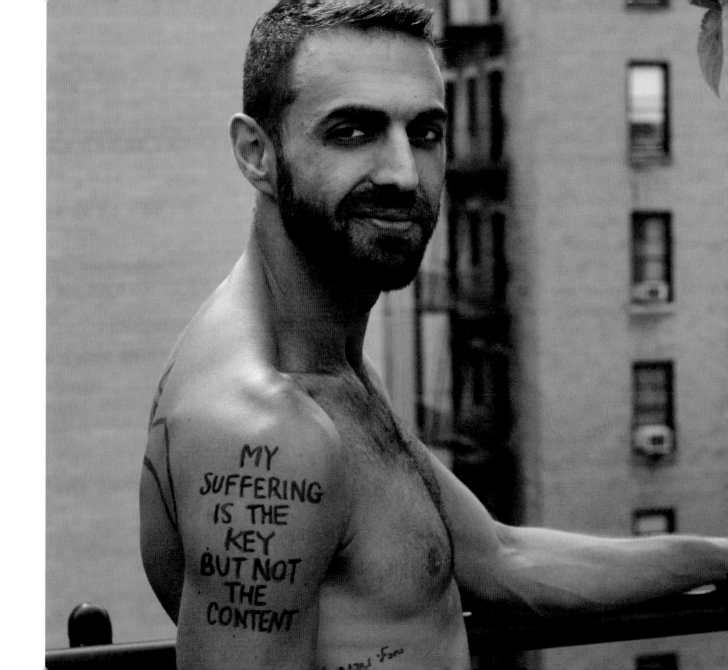

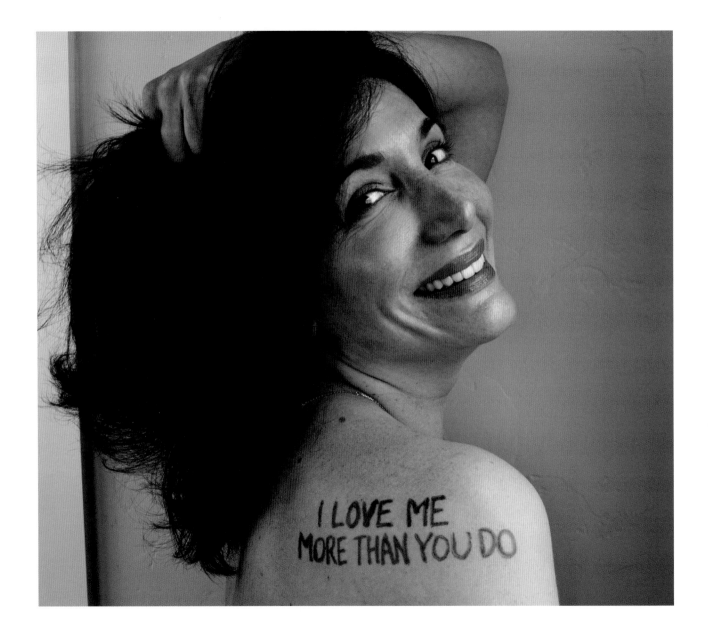

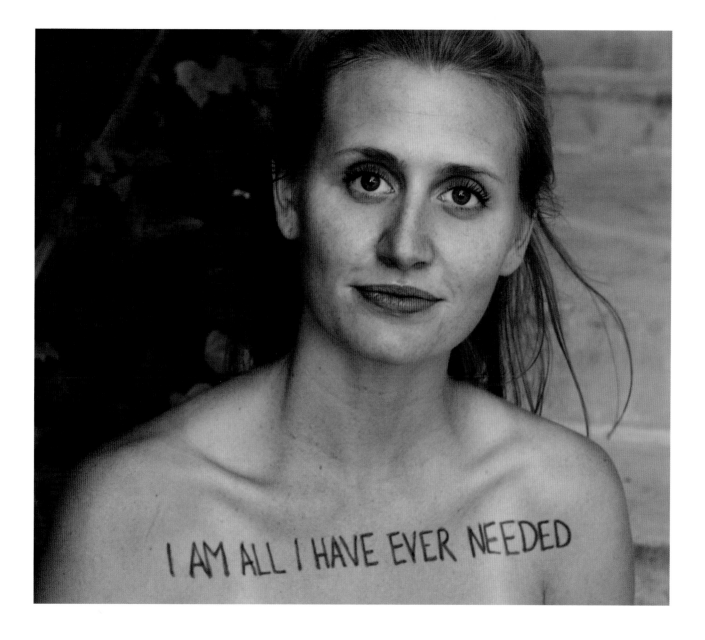

I REMEMBER THE FEELING OF LOSING MYSELF WITH SOMEONE ALL TOO WELL.

There was a time in my life when I was not representing my true authentic self and would not have been able to write those words on my body. This picture symbolizes my growth. In relationships, sometimes you can lose pieces of yourself in another person. Through growth, I know now that it is so important to always remain true to who you are, no matter the pain or process. Love for yourself is such a beautiful thing. I am so happy I have learned to embrace all that is me! I absolutely love the woman I have become and see in the mirror today.

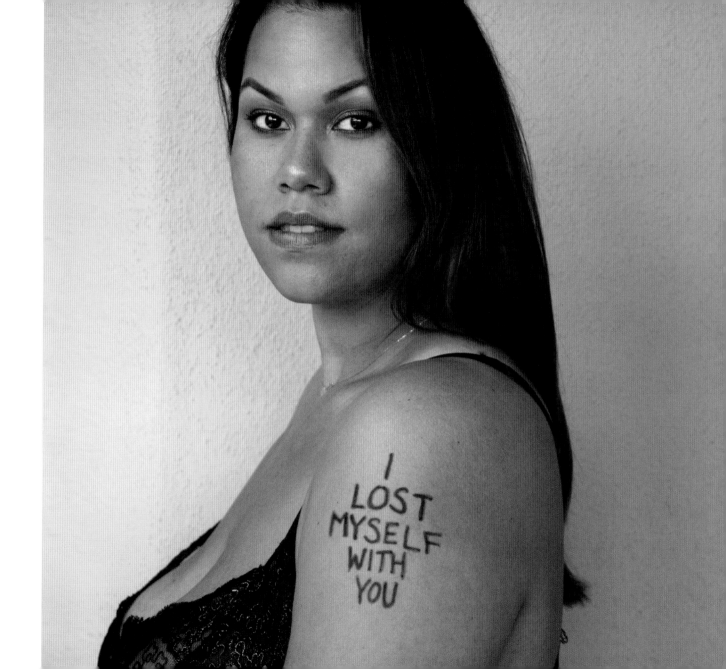

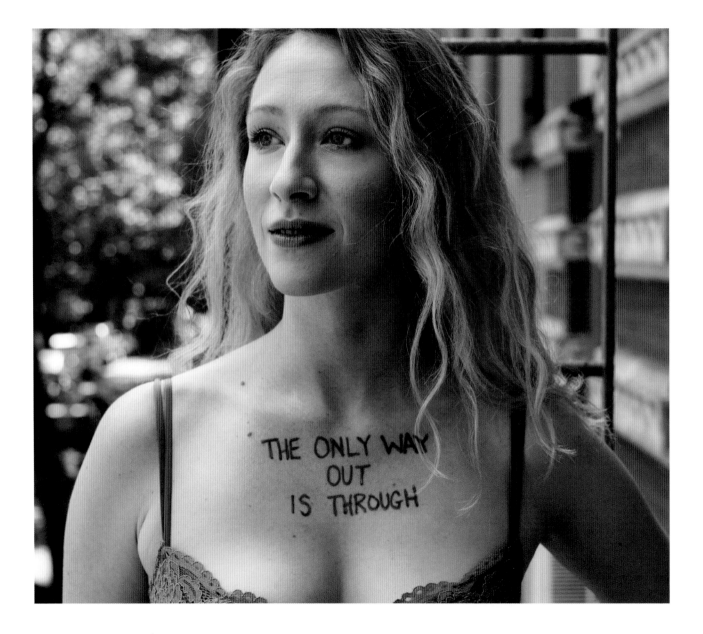

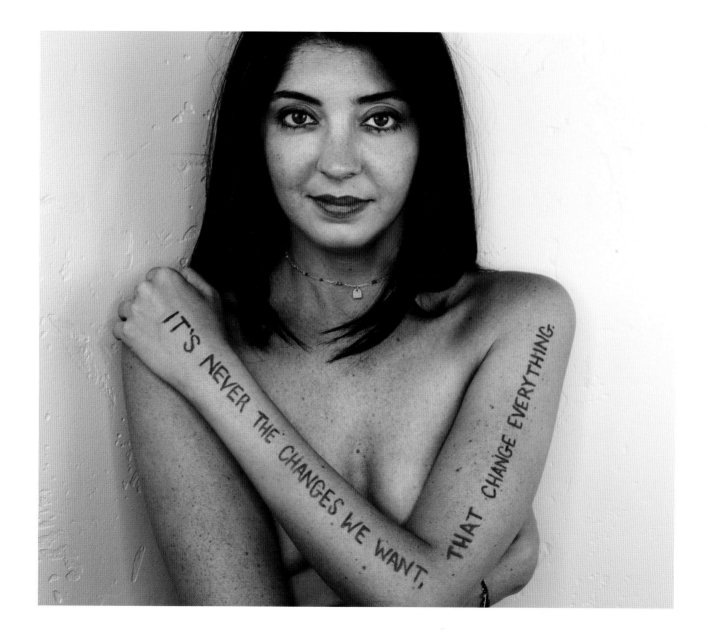

You can't be in it for the real of it,

Say you just don't want to deal with it,

So you steal from my trust,

And it is becoming clearer and clearer

That you feel more for your dealer

Got more stakes on white lines and glass mirrors

Spent more cake on fake feelers

But my bones are shaking,

And my soul is faking,

And I know deep down …

This. Shit. Ain't. Right.

So, I refuse to be the casualty of one man's war with himself.

Not today,

Not tomorrow,

And not for one more single night.

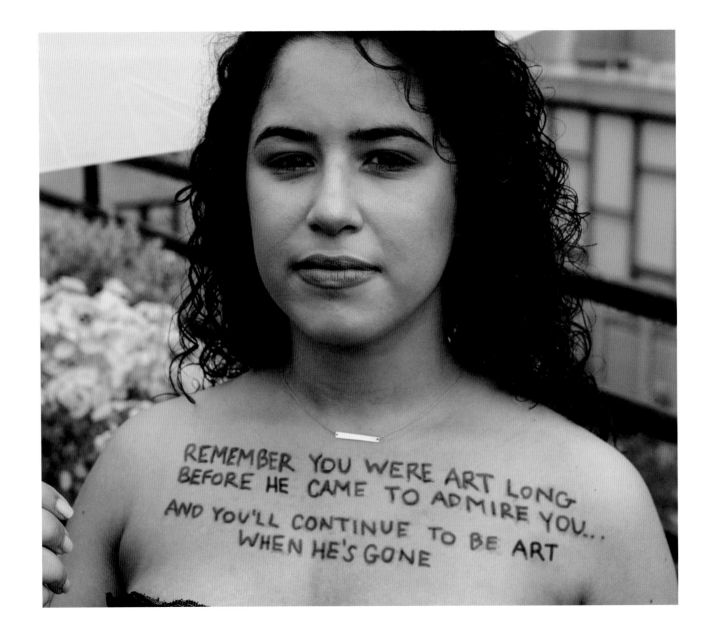

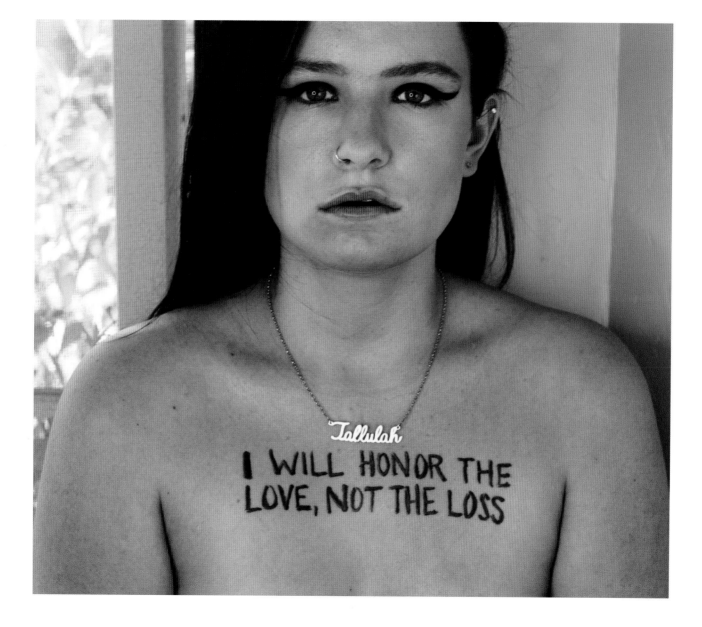

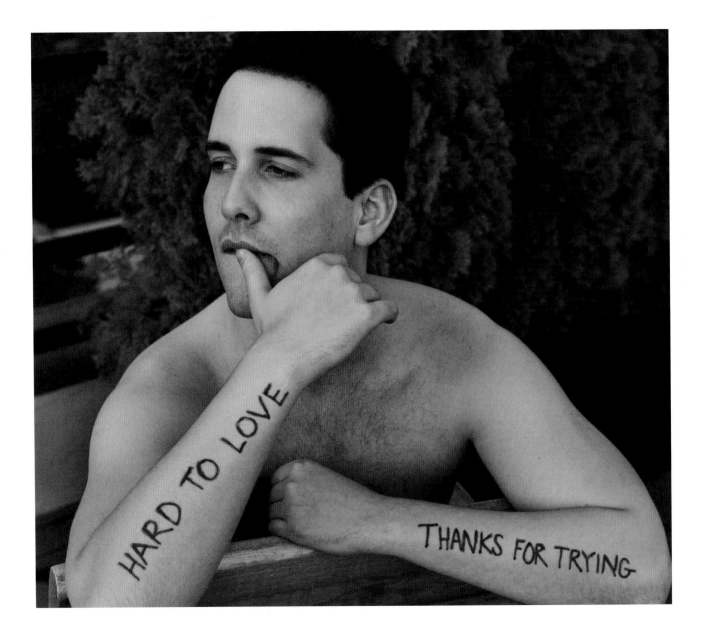

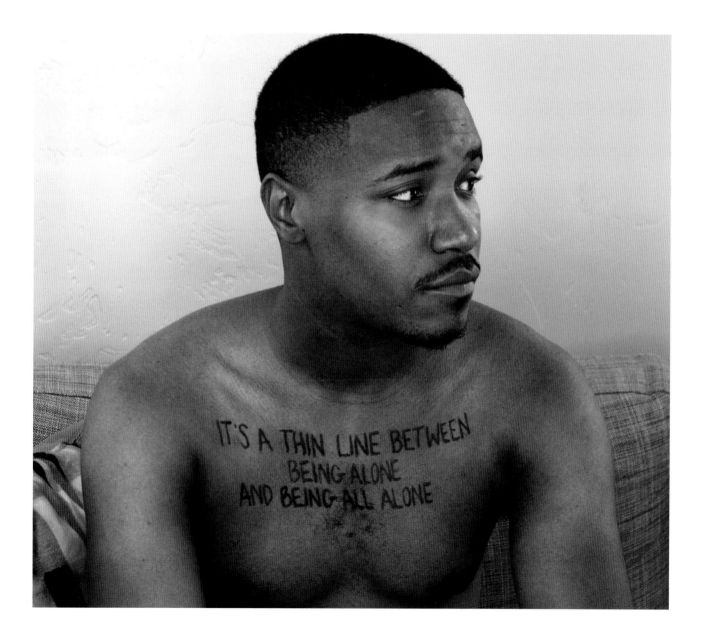

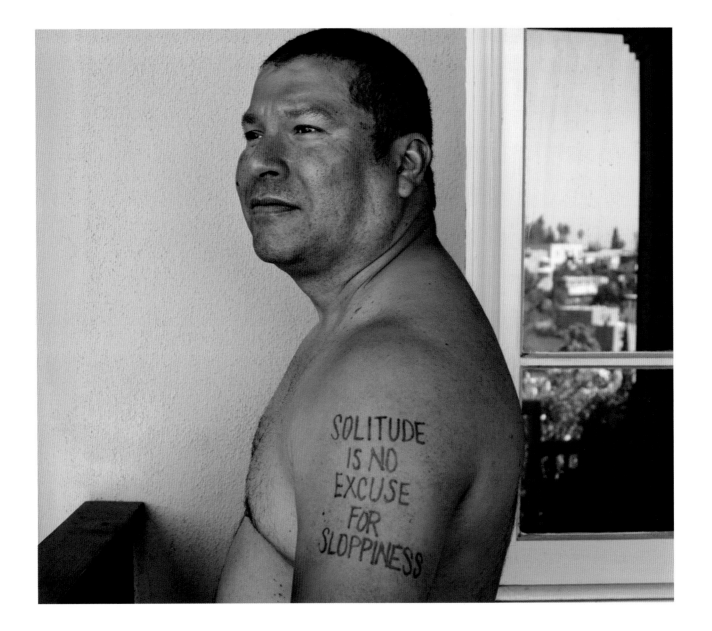

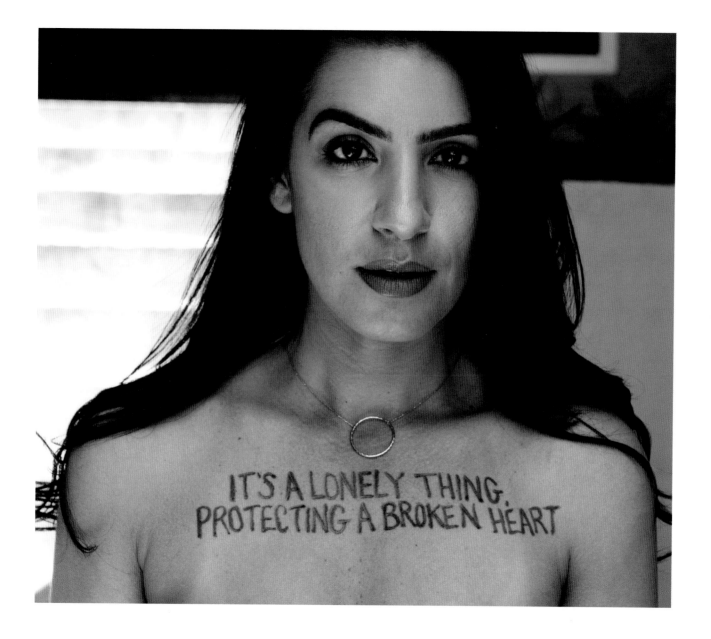

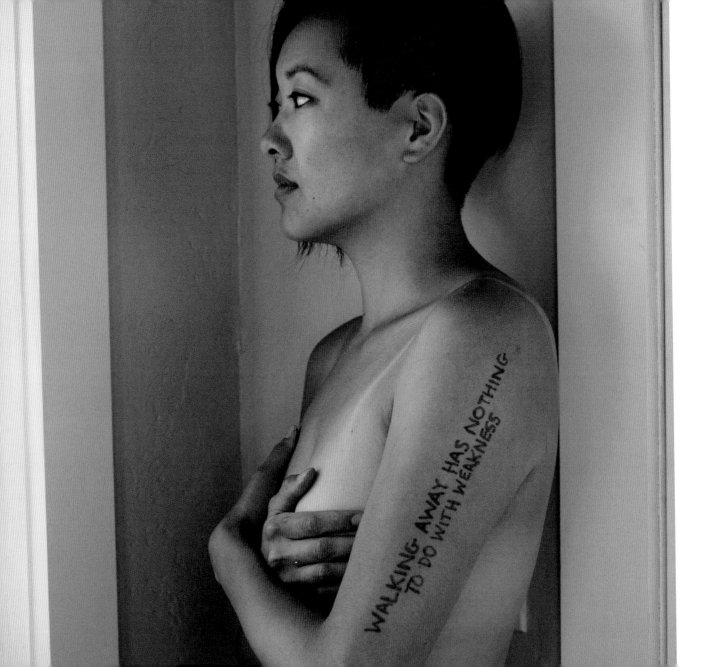

IN 2015, I FINALLY MUSTERED UP THE
COURAGE TO END ALL CONTACT WITH
MY MENTALLY AND PHYSICALLY ABUSIVE
FATHER—I LET HIM KNOW I WOULD NO
LONGER KEEP IN TOUCH WITH HIM UNLESS
HE GOT PROFESSIONAL HELP.

I have not seen or spoken to him since then. A year after, I left a job in which I invested so much of myself working toward empty promises of partnership and future ventures. It was more heartbreaking than creating those boundaries with my father. In both instances, moving on from the hope that things would get better was the most challenging part. I am healthier and happier now without my father's influence and by choosing to intentionally live and pursue a lifestyle that is filled with an abundance of opportunities. Walking away has everything to do with self-love and is sometimes the only way to find real peace. If you don't feel safe and respected, then you have the right to walk away. And must.

I SPENT YEARS BEING EMBARRASSED
BY HOW MANY TIMES I HAD
EXPERIENCED UNREQUITED LOVE.

I felt drained by constantly giving and receiving nothing. Then, I made the realization that my vulnerability was a virtue. I had turned my biggest strength into a weakness, and it was time to reclaim my power. Where I give love there *is* love, and that is enough. I'll scream it from every rooftop or tattoo it on my forehead before I ever let myself be ashamed again.

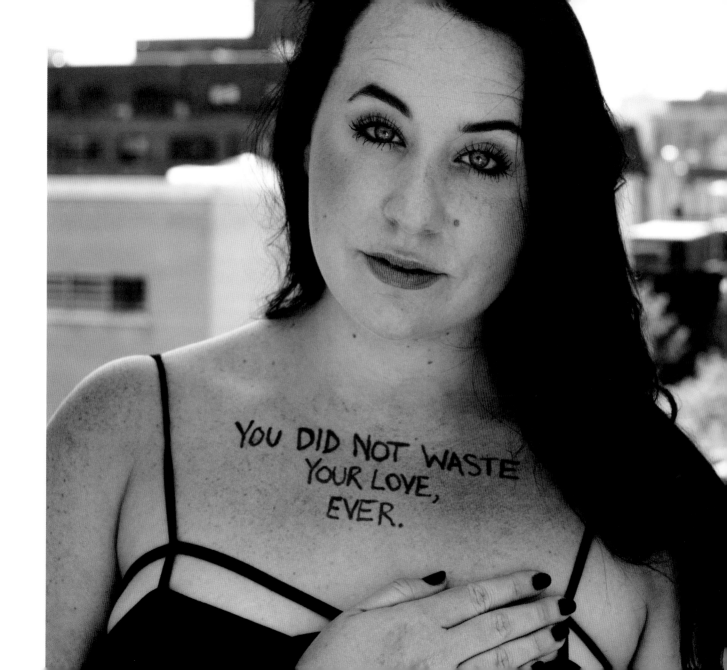

THIS IS A GOOD SIGN, HAVING A BROKEN HEART. IT MEANS WE TRIED FOR SOMETHING

OPENING YOUR HEART TO SOMEONE
(OR SOMETHING) MEANS RISK.

Risking the possibility of pain, disappointment, sad-
ness. I've cried on subway platforms, replayed old
messages, felt worthless and undeniably alone. But
looking back I don't regret any of it. It's made me
stronger, made me look at myself in a deeper, more
compassionate way, and shown me that I have the
capacity to love fiercely and without shame. I'm
grateful for that.

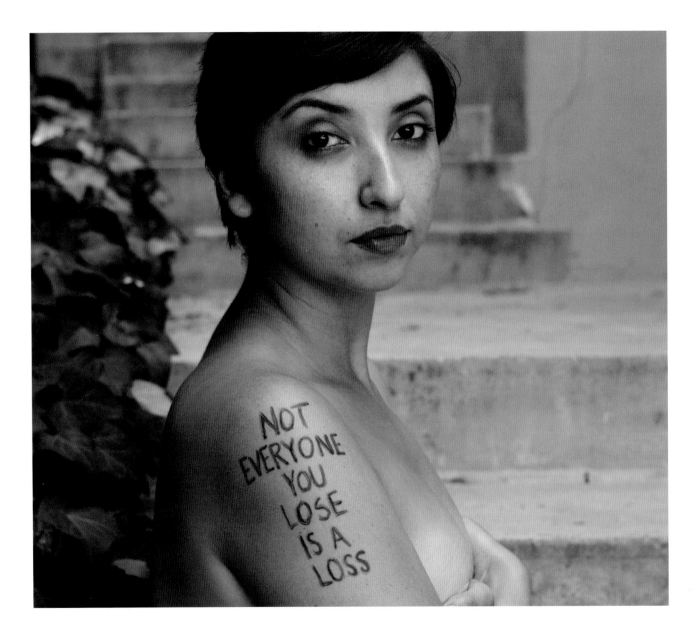

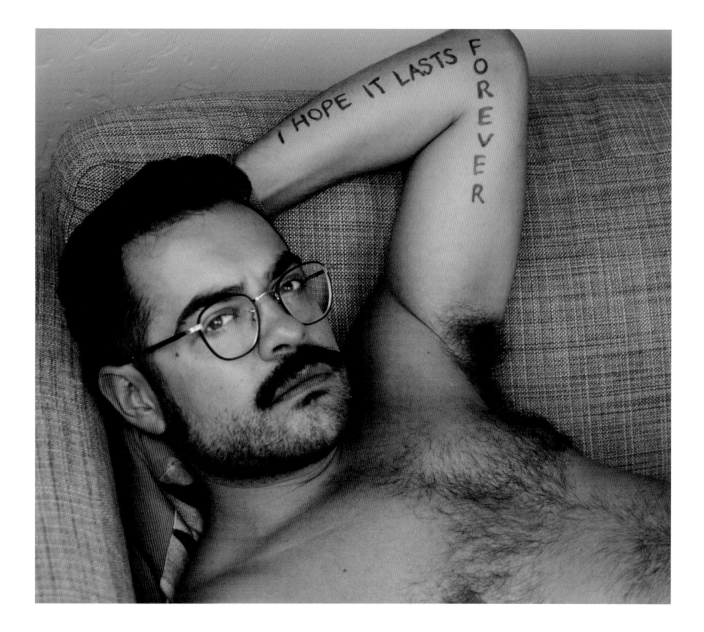

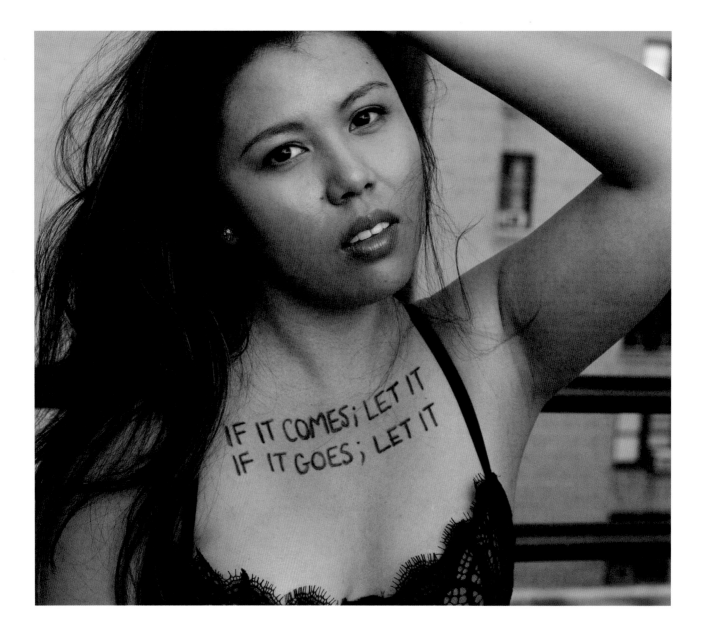

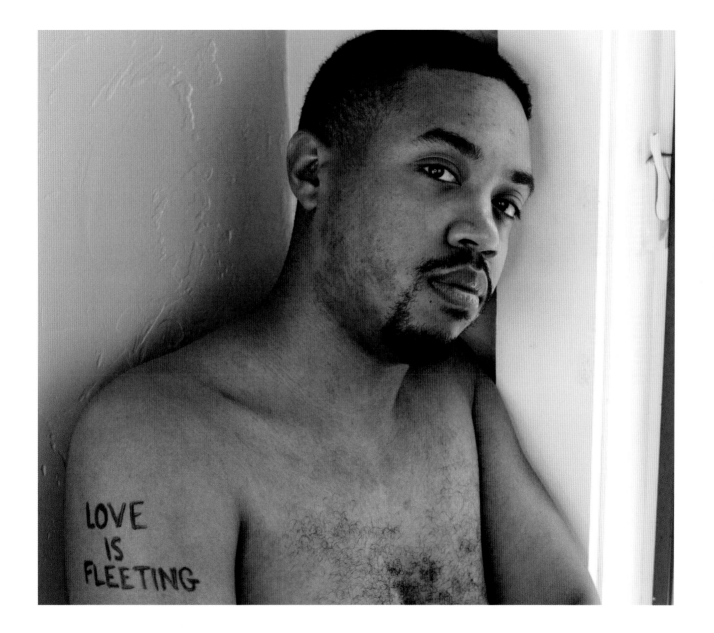

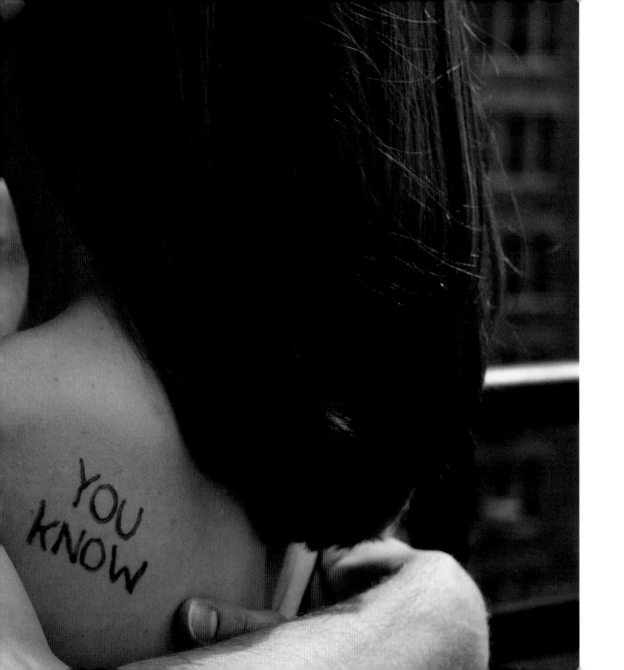

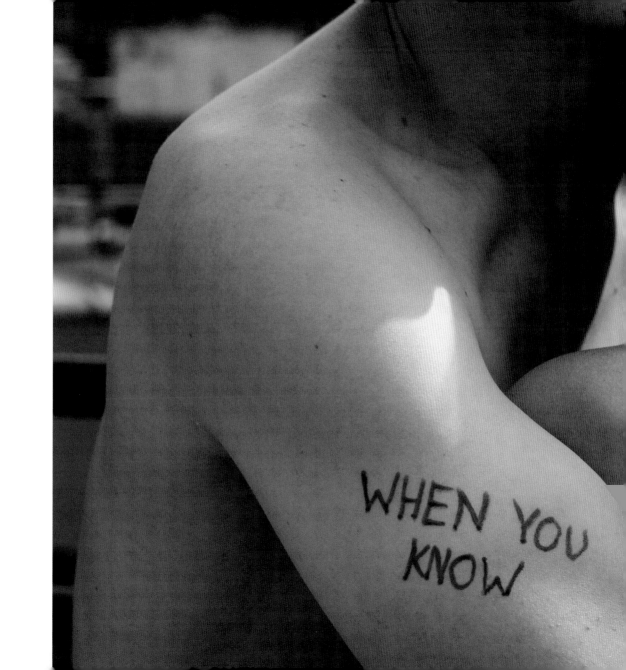

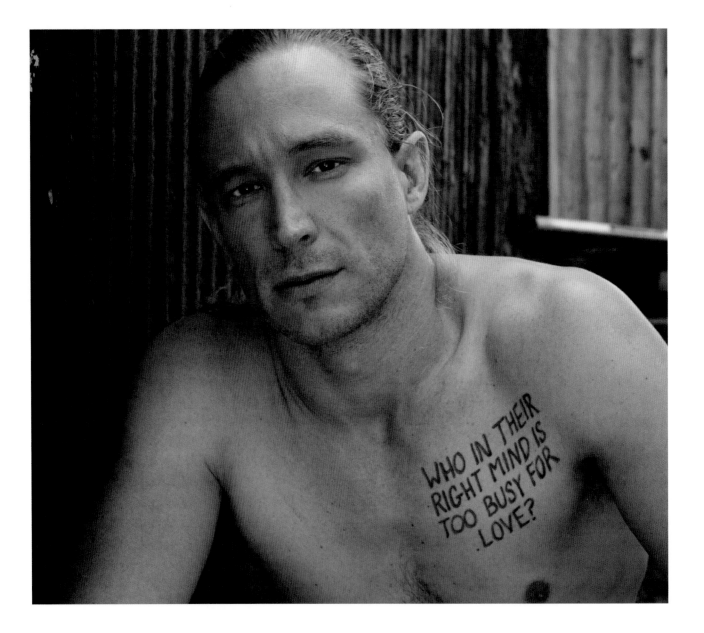

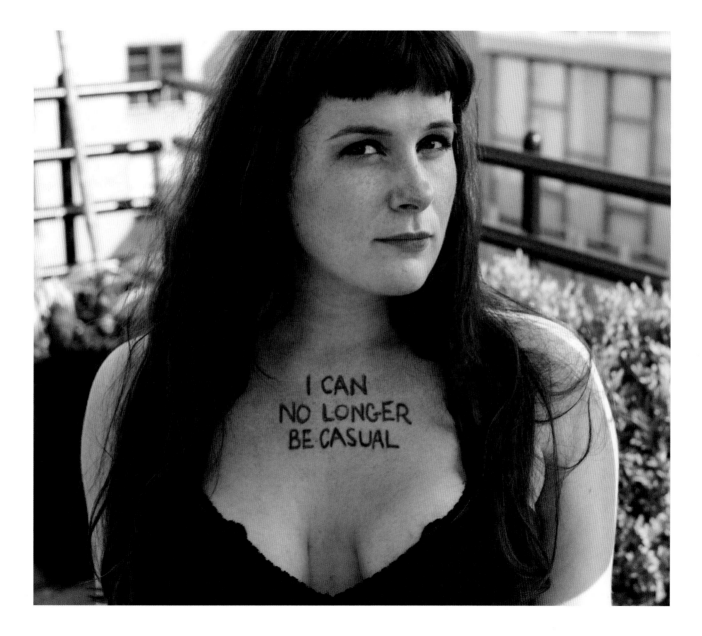

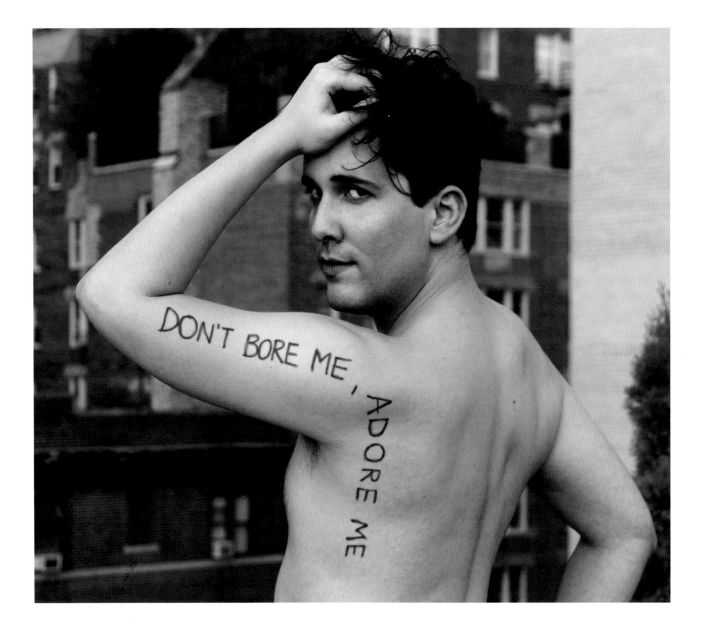

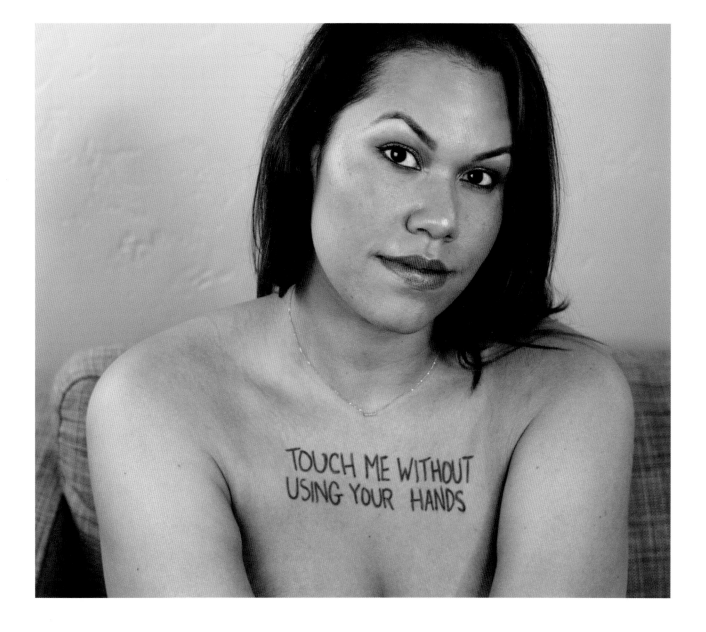

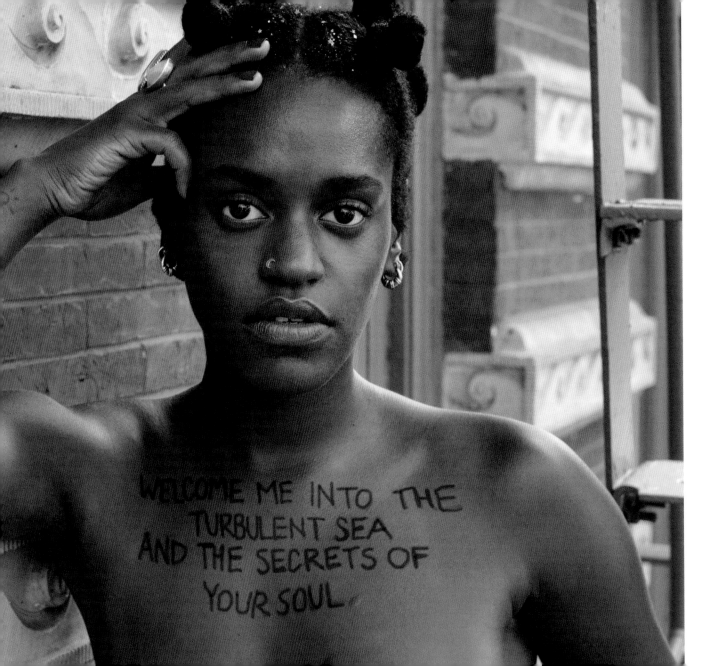

I don't want to sit in a teacup on the merry-go-round of yore
 and yesteryear

Cause I'm not that person anymore

I wanna be here

In the present with the acid trip of being alive

The patterns of your flesh and mine while different can collide

If you welcome me into the turbulent sea and the secrets
 of your soul

That you think are much too precious to be told

Uttered only in passive aggressions and cliffhanger sessions
 of "catch me if you can"

But finding ourselves here is part of the greater plan

Like mermaids belong to the sea and silkies to the struggle

We're meant to find each other and all I wanna do is love you

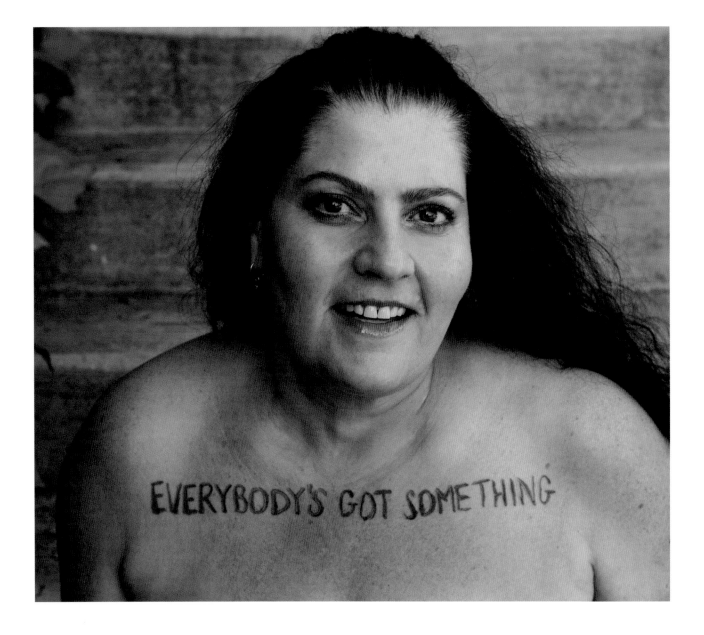

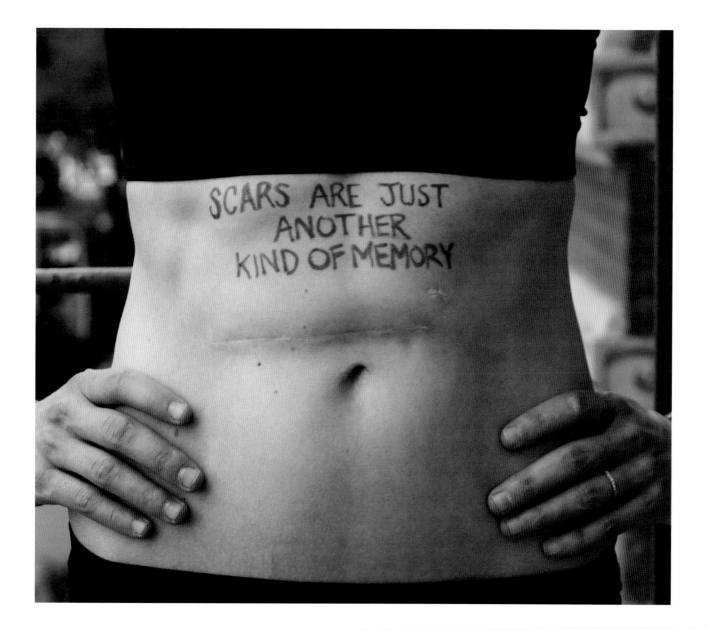

ALL MY LIFE I'VE WANTED TO LEAVE A MARK.

The pressure society places on women to be beautiful is very real. I struggled with my weight my whole life, and last year I had gastric bypass surgery. After the weight loss, I felt even more insecure because of my excess skin. So I had a tummy tuck and breast lift. I've learned that I still want to leave a mark, but I want to leave a mark for my husband and my kids. To show them how important it is to be healthy and strong. I want to be around for a long time … for them and for myself. I don't care about what society thinks is acceptable anymore, and it's my goal to teach my daughter the same thing.

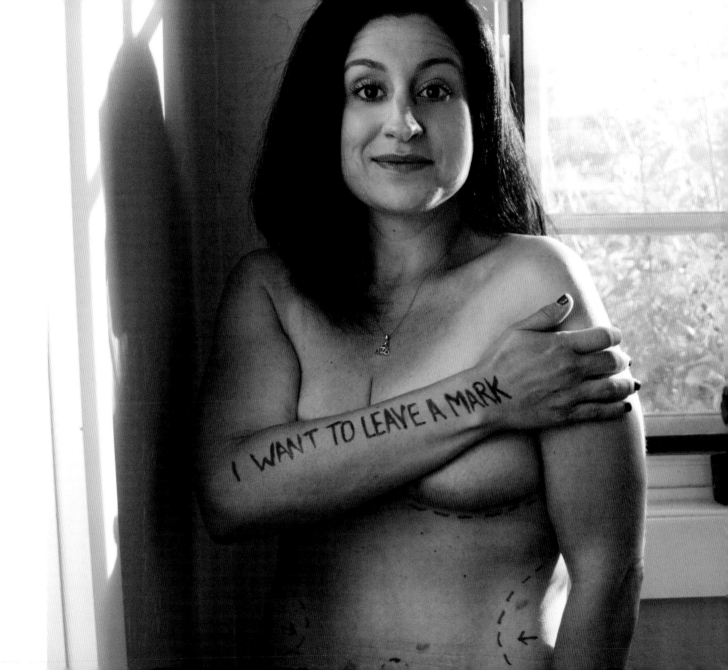

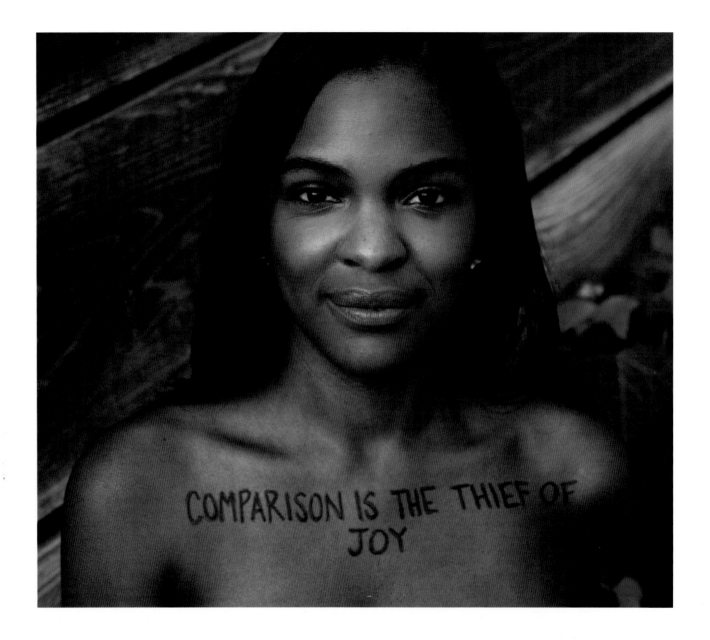

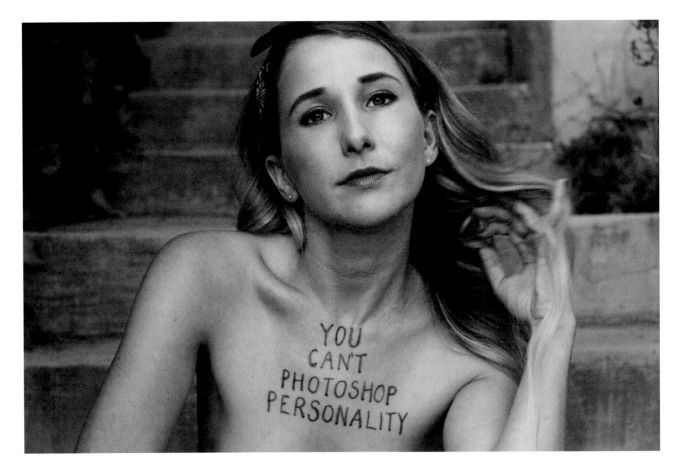

I am a confident, independent woman, and I feel I am wasting my days checking to see what people are up to on Facebook and Instagram. Lately, I have been comparing myself to other women on these apps, which I had never done before. I am picking apart my body. Wishing I was thicker or thinner in areas and wondering if I need to post sexy selfies to keep up. It's starting to feel toxic, but I am not sure where to set boundaries. I am envious of women I don't know and will most likely never meet.

Make your choices carefully. Listen to your good voice (she's always right). Everything will not work out exactly the way you planned. Don't dwell on the shit. When life hands you lemons you don't have to make lemonade, just call your closest friend and cry it out. But make sure the next time you speak to her you give her a chance to cry it out, too. She'll be a lifer after that. Choose to be happy. Stick to your instincts and make your own magic happen. That, my friend, is your power.

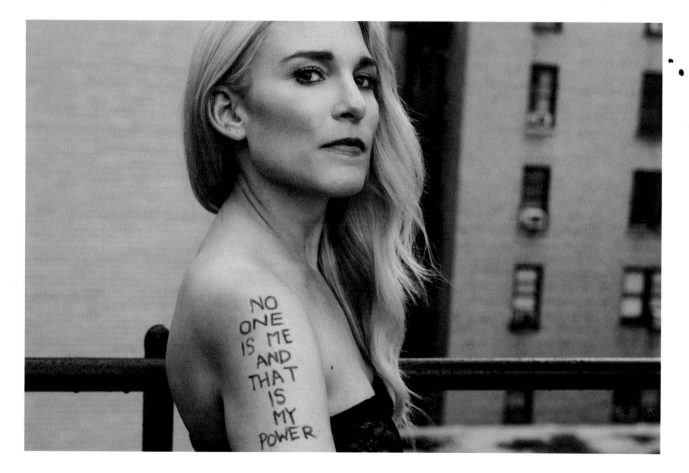

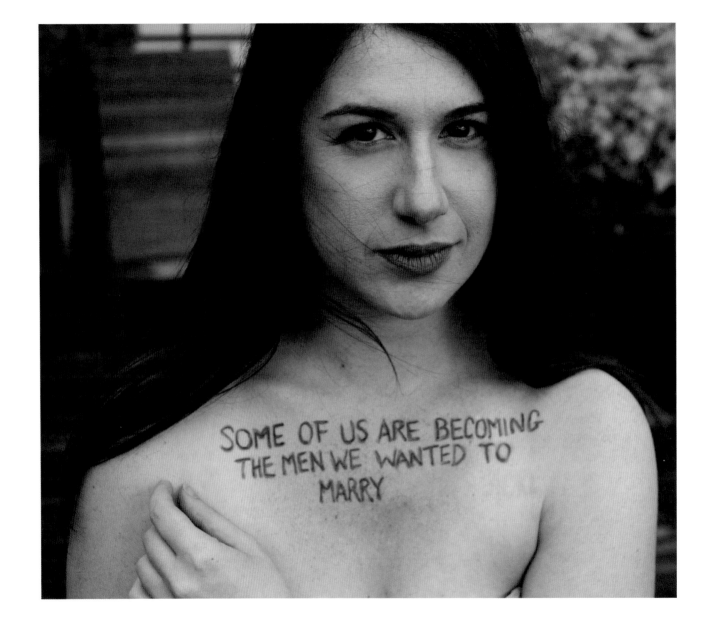

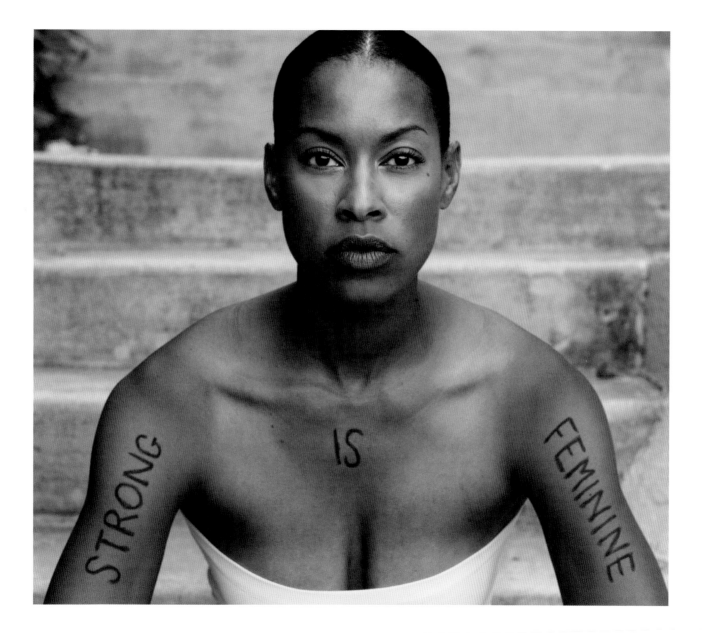

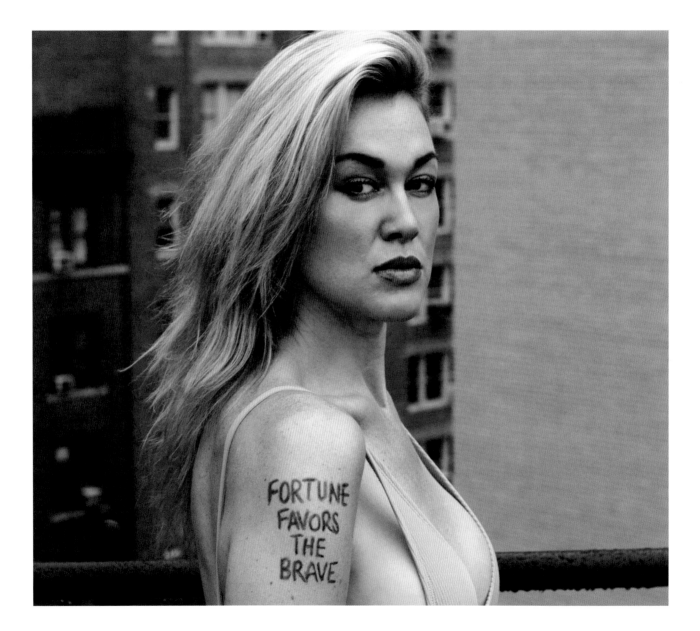

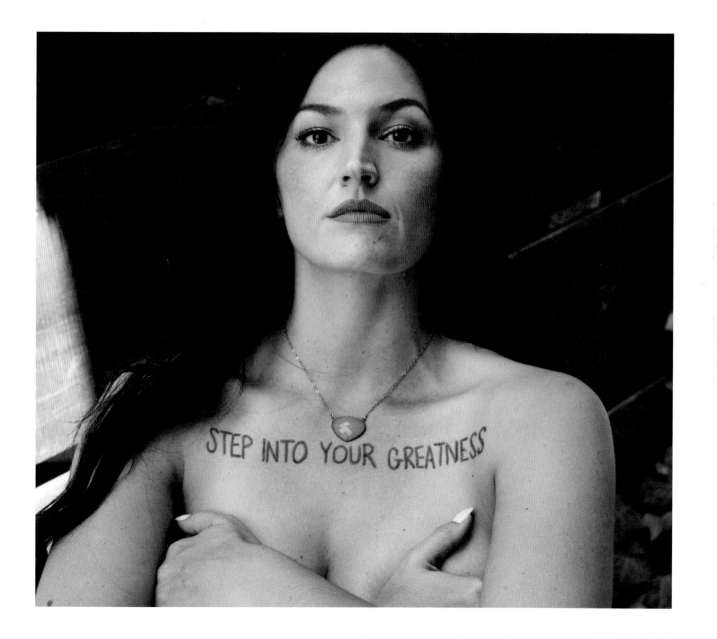

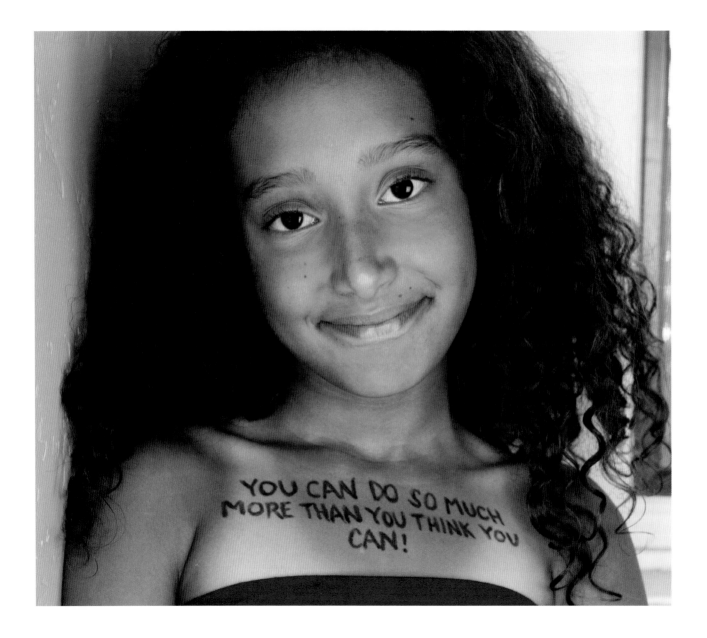

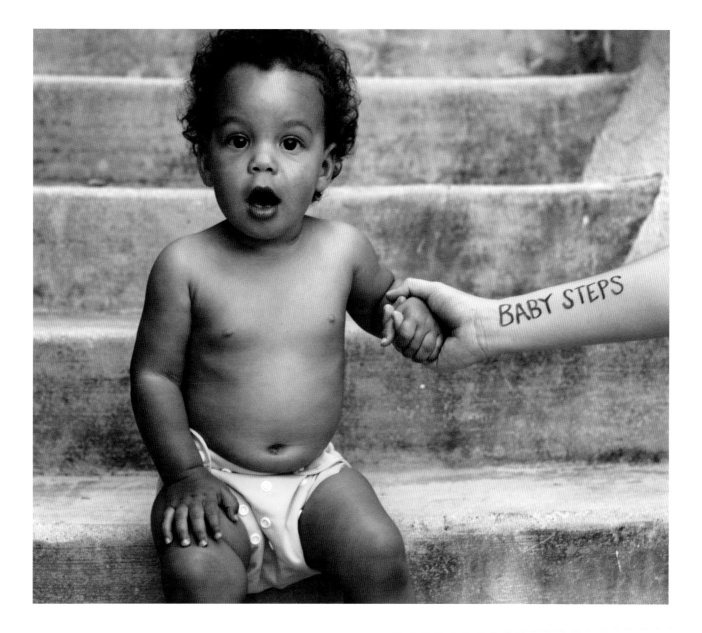

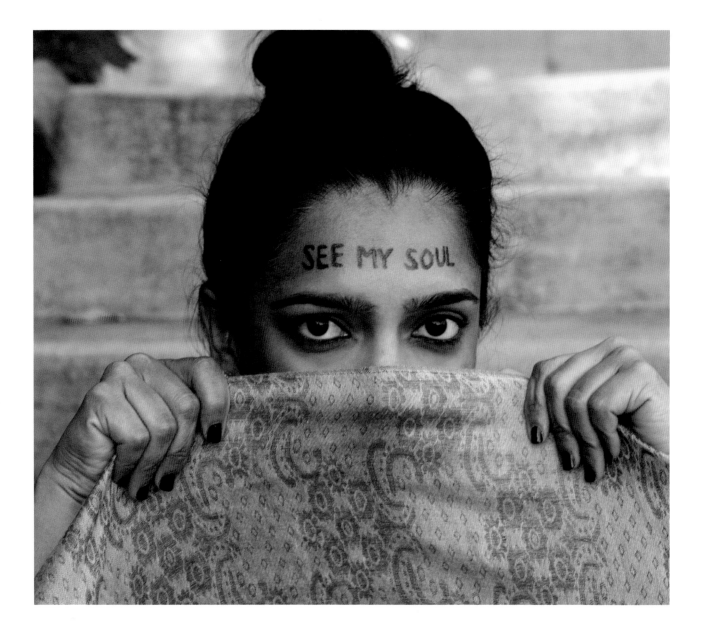

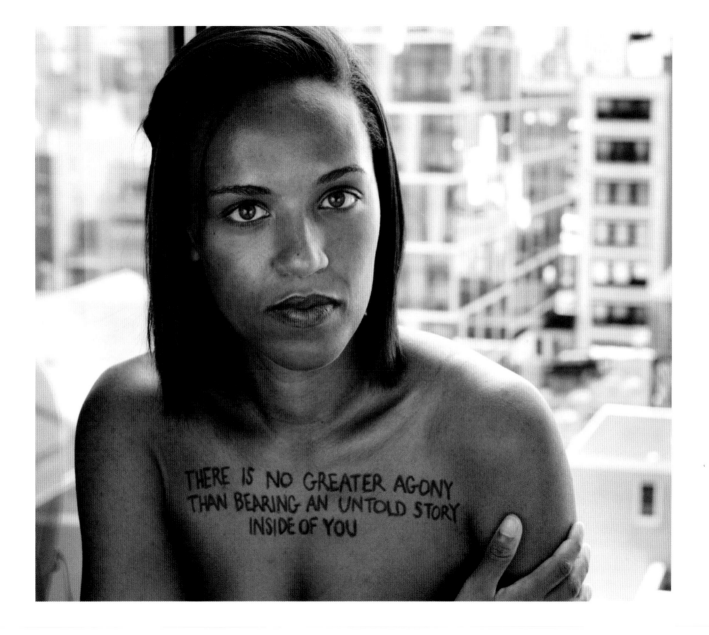

I'm black. I'm gay. But I fit neither box completely. Still, society is constantly trying to force me neatly into one. It feels almost as if the world is a child and I'm a new food that they won't enjoy until after they have been forced to taste it. A unicorn isn't just a horse with a horn; it's a magical creature. And I have to remember that so am I.

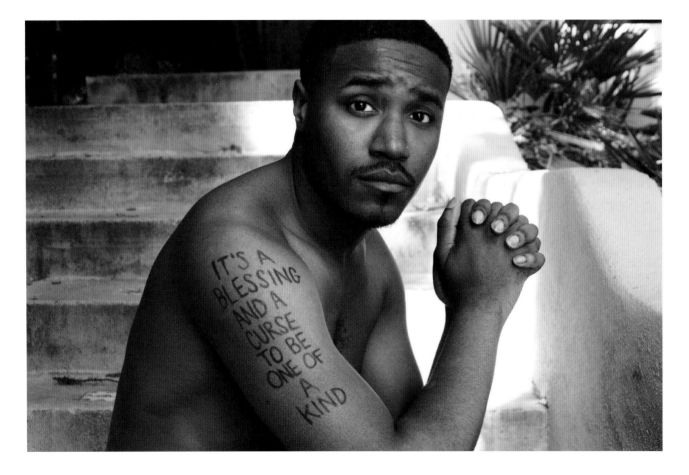

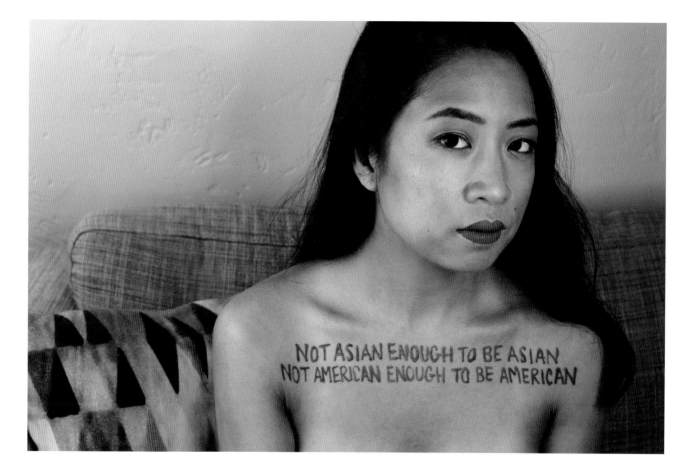

When I moved to LA to pursue acting, I quickly found out that people in this business love to put you in boxes — "Know your type," they say. As a Filipino-American woman who grew up in the Midwest, I often feel like I don't fit into any of the boxes. I feel like an American, but seemingly can't be accepted as an All-American Girl. I also don't fit most East Asian roles, as my dark skin disqualifies me. I once even auditioned for a specifically Filipino part — but I don't speak Tagalog, and was too American-sounding to pass. After that I felt so lost, like there was never going to be a place for me. But now I've realized I'll just have to make a place for myself.

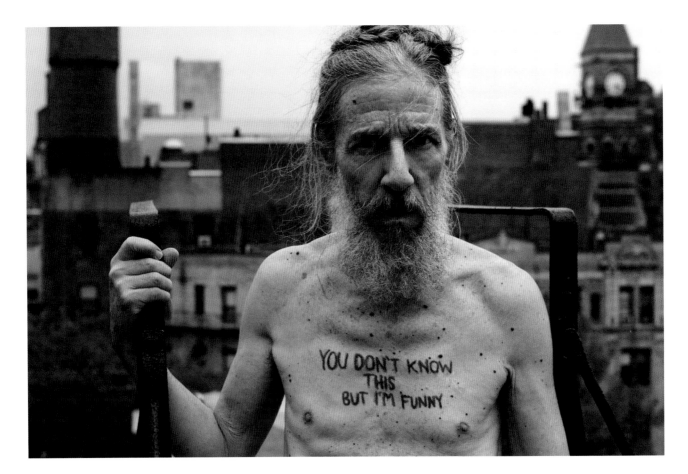

"You're funny, Frankie, and you're always dreaming!" I often heard that growing up. I guess they were right! Now, I realize being funny is really who I am. I am an actor and yesterday I played a sad homeless man, today a death row inmate, and tomorrow an evil Wiccan character. It certainly is a funny way to make a living. I always remember that song from *South Pacific* that says you have to have a dream in order for your dream to come true. Everyone must find their own funny, creative dream, follow it, and one day it will come true!

People look at me and assume I should be a certain way. People have always questioned my last name and were confused by it. I guess they don't expect an Asian woman to have the last name "Brown." They talk to me or treat me a certain way because of my outer shell. It's possible that I disappoint others when I don't conform to their stereotypical expectations. The real me? I was adopted by ex-hippie non-religious Jews from Brooklyn. I'm a vegetarian. I am a teacher. I am a daughter who has my mom's laugh and my dad's dry humor. I am hard to describe, but I am ME.

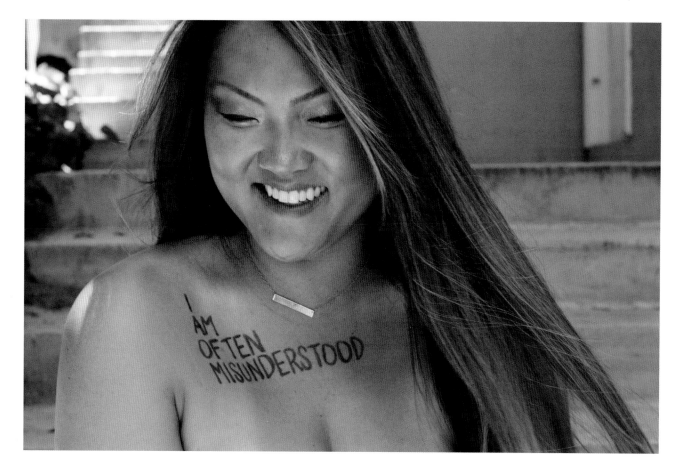

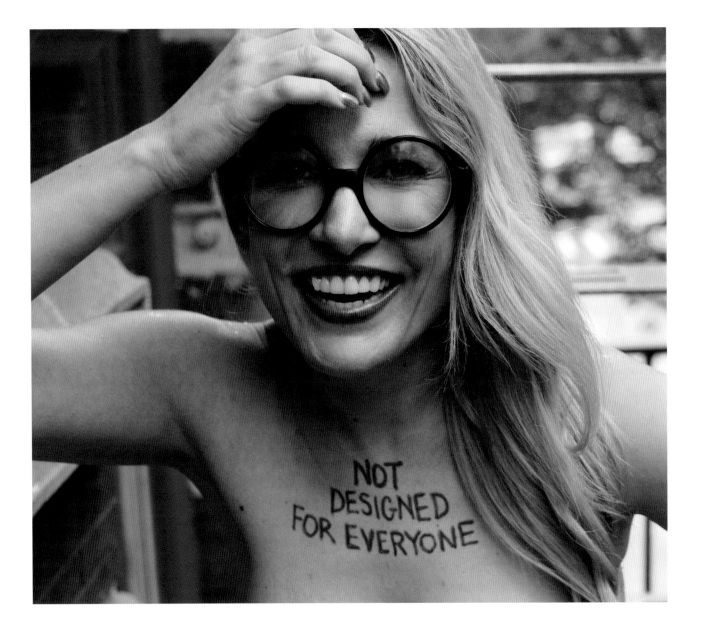

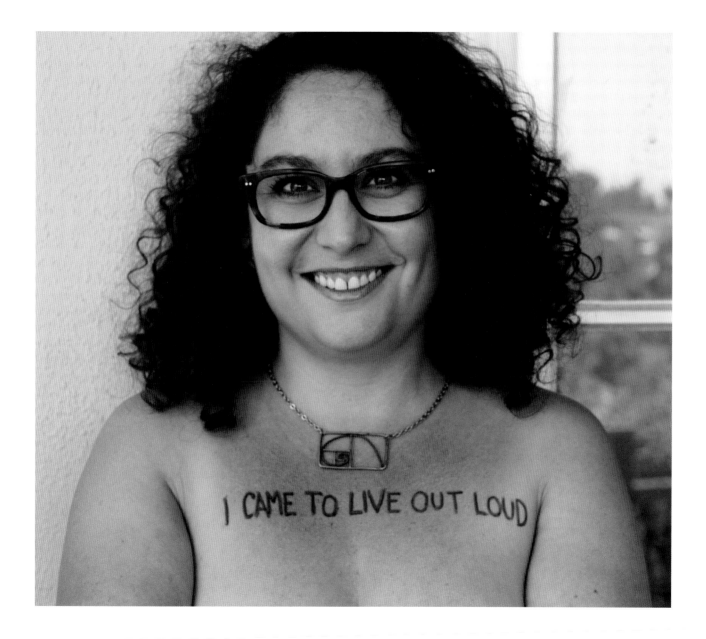

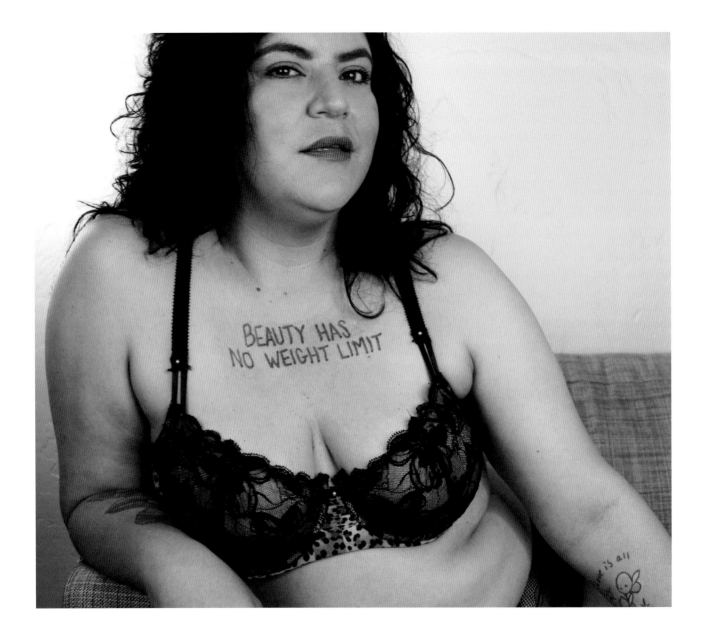

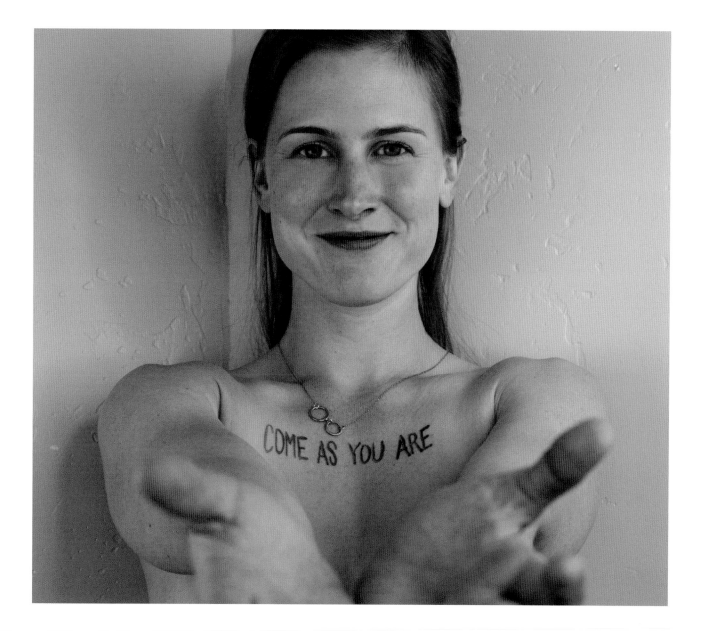

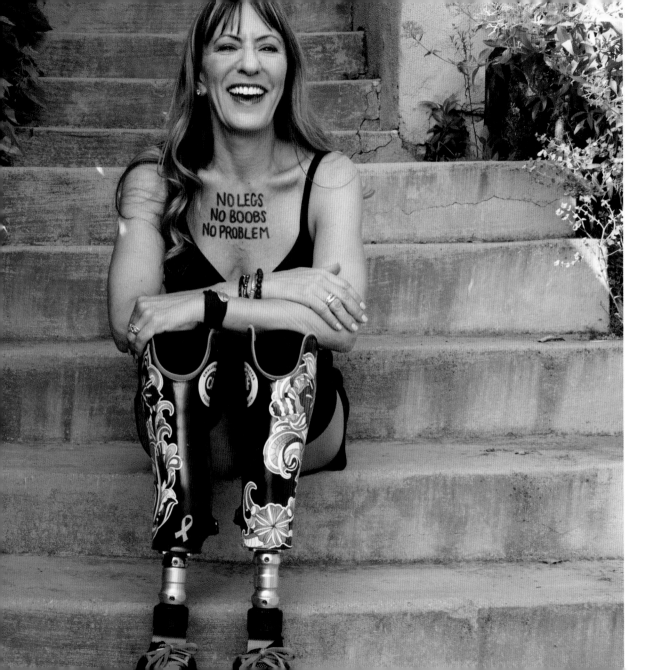

I AM THE REAL BIONIC WOMAN!

Growing up I did not hear the word "prosthetic," nor did I understand what it meant. Now I start every day by putting on my bionic legs. I had both my legs amputated at age nineteen due to frostbite. I could have never imagined that I would find myself having to live in my car for eleven days during a terrible snowstorm in a desolate area of Northern Arizona, but it happened, and I not only survived, but I am thriving with a love for life. Thirty years ago my life was saved to make a difference for all those I meet, and that has given me tremendous purpose on my spiritual journey of life. I have learned to embrace my "different abilities" by performing incredible athletic feats that I would never have conquered with my "real" legs. As we all know, sometimes our path takes a turn that we don't want or even fear. That is where I am now. Breast cancer has forced me to embrace spiritual and emotional demons that have been buried for quite some time. During this process I have begun to slow down, while using mindfulness in every step of my life. I accept the challenge of getting to know myself more and more every day.

LIFE IS A SCARY, BUT VERY REWARDING,
JOURNEY OF SELF-ACCEPTANCE, LETTING GO,
AND RECONNECTING TO OUR AUTHENTIC
SELF—MIND, BODY, AND SPIRIT.

I have come to realize that true learning is unlearning. I've allowed myself to experience the gentle, yet powerful, shifts of removing learned behaviors from my life. I work to refrain from repeating old, toxic patterns and wounds that no longer serve my highest good or the good of others. I remind myself to get out of my own way. Rather than showing up as the person that I am, I want to show up as the better person I know I can be. "Learning to Unlearn" gives me the gift of getting to know my genuine, uniquely Divine, and authentic self. This has taught me how to forgive and love myself and others unconditionally. I am so grateful for this breakthrough. Day by day, I fall more and more in love with the person I see in the mirror, and for that, it has all been worth it. Growing toward self love + universal love + unconditional love is such a rewarding and wonderful journey to be on!

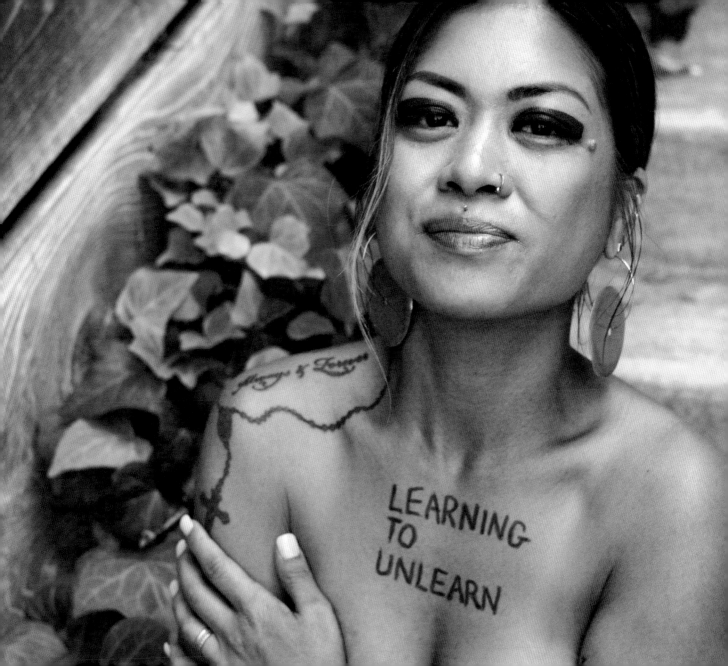

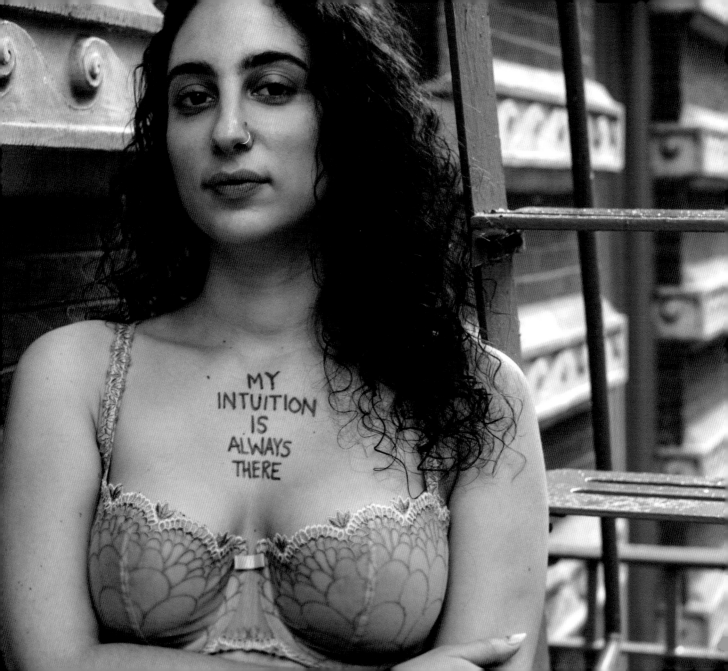

THIS PICTURE WAS TAKEN
THE MONTH I TURNED THIRTY.

It's made me feel super existential, and it's both hugely unsettling and amazing. I've never felt more appreciative of time, feelings, people, and the world around me. It has gradually become clearer to me that this really is the only life I'll get and that some of the things that I thought would happen just won't and that other, more amazing things still can. I'm learning to trust myself, to hear my real voice, and let go of the things that don't serve me. It's awesome.

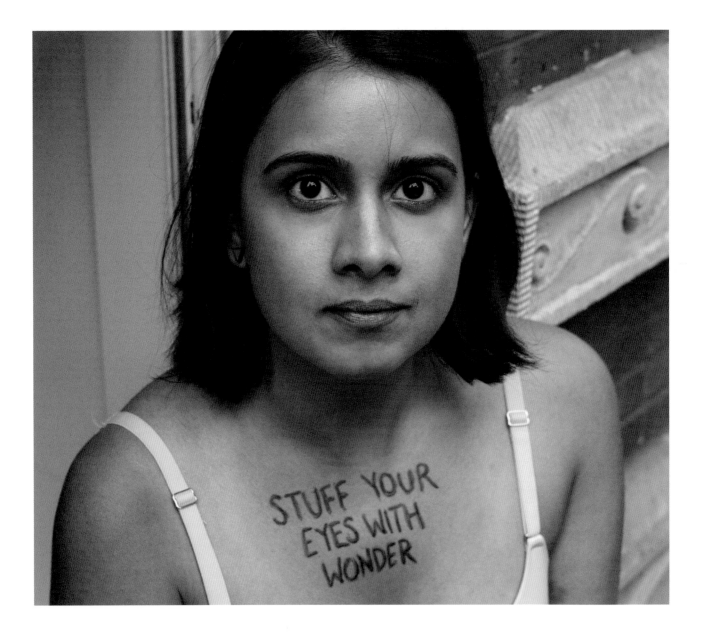

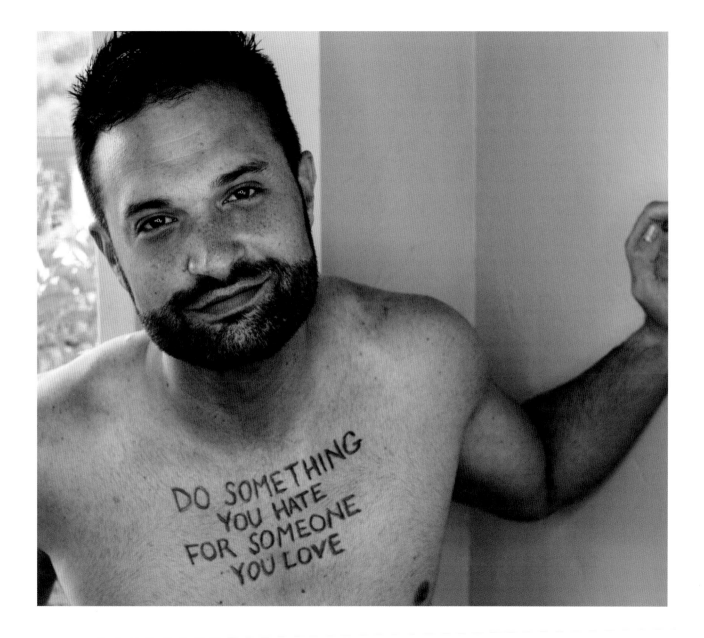

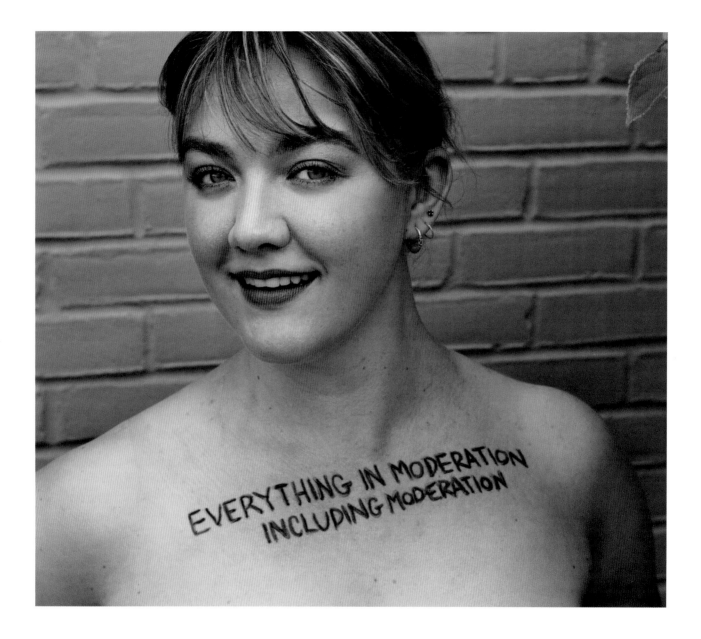

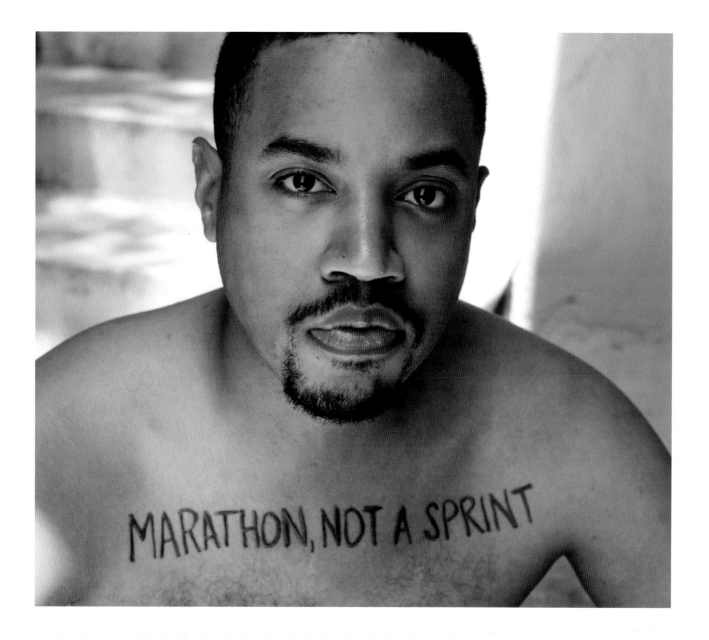

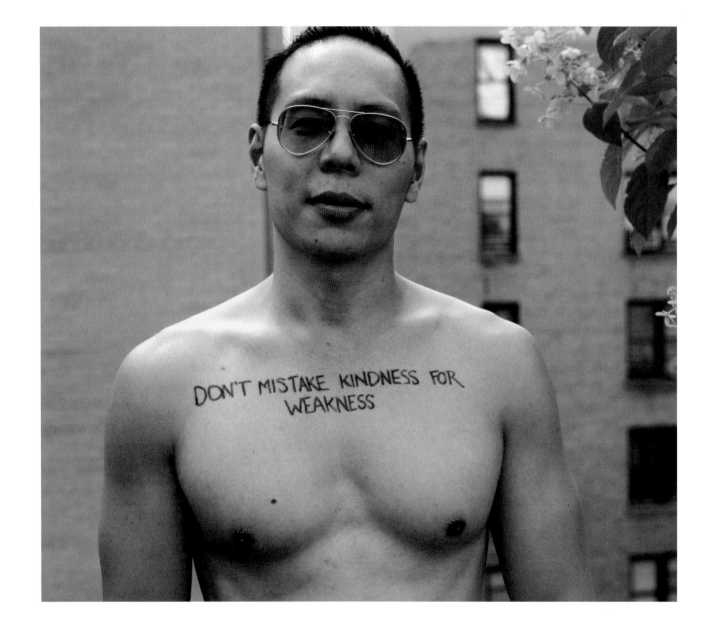

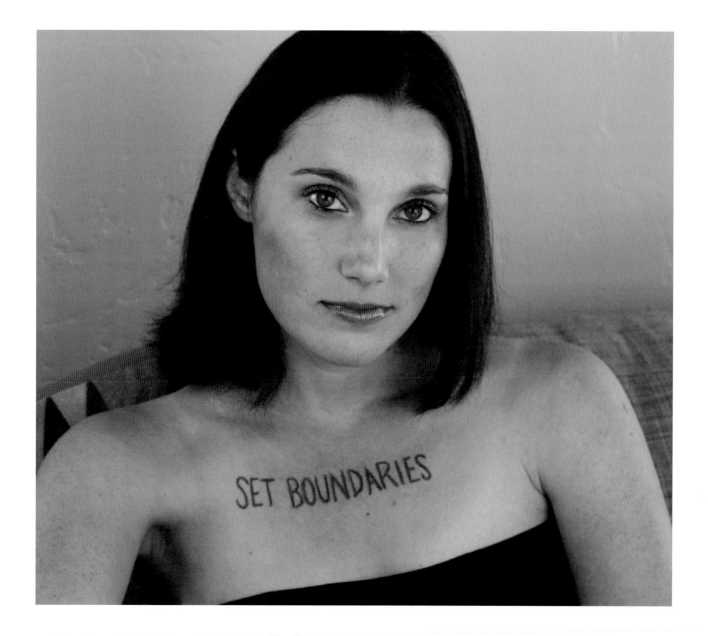

AS A BLACK WOMAN, I LEARNED VERY EARLY THAT I WAS "DIFFERENT" AND WAS TOLD I NEEDED TO WORK HARDER AND BE BETTER THAN EVERYONE ELSE BECAUSE OF IT.

I learned the true meaning of sacrifice, as I quickly deleted layers of my truth, hiding parts of myself—even from myself—to be as everyone else needed me to be. I constantly felt empty and unhappy. There were many lonely, sleepless nights and tears. I couldn't understand why I wasn't happy. I'd done everything I could to make my life easier; I was living the life I was told to live. What was I missing? What did I overlook? One ordinary moment, I gave permission to my authenticity and belly-flopped off the high dive into the magical parts of life. In fleeting moments I would experience my own powers of creation and slowly began accepting them, accepting what I so long ago rejected. Bit by bit, I have come to realize it was those lost parts of myself that I was seeking; it is my "different" that has been my siren song.

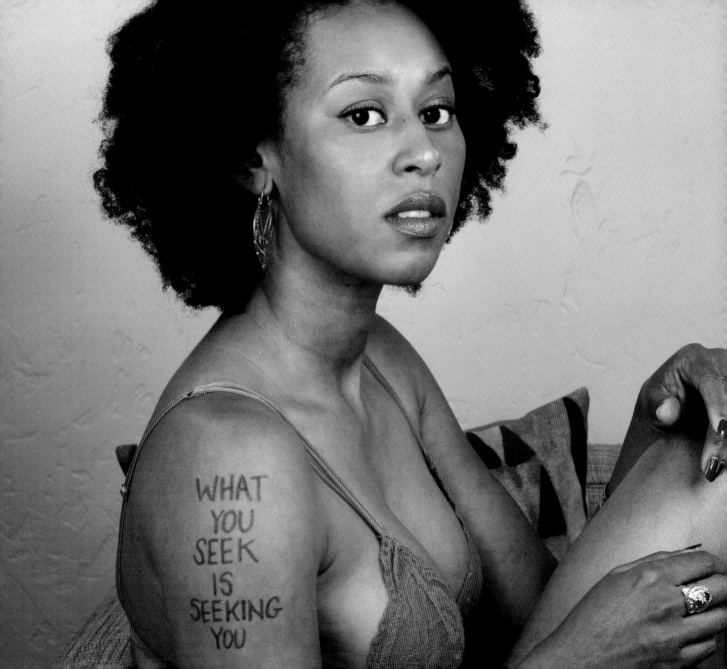

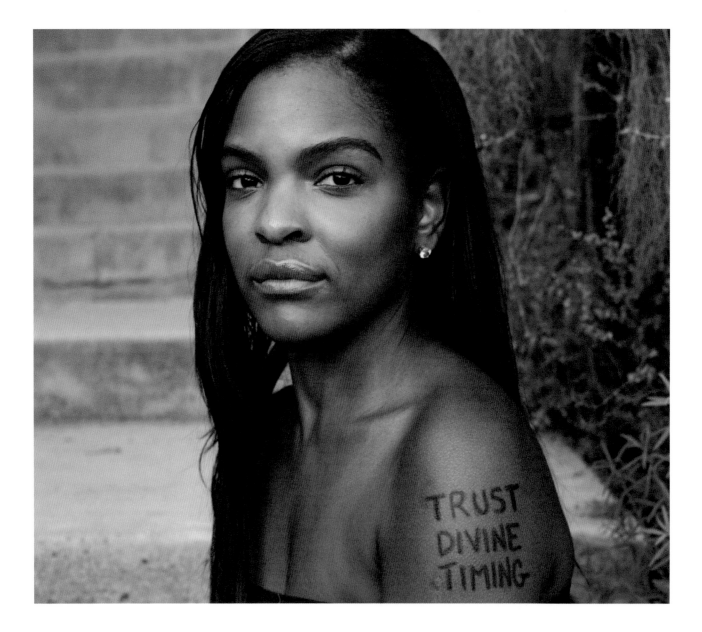

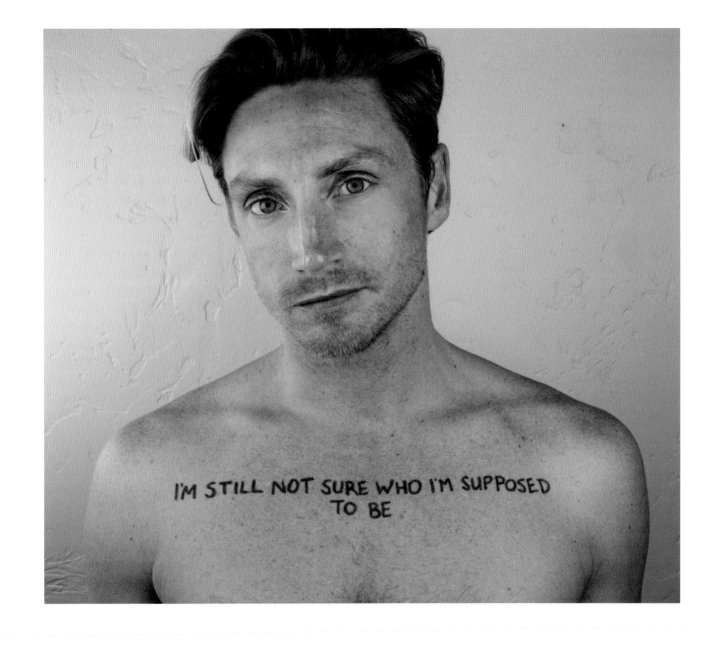

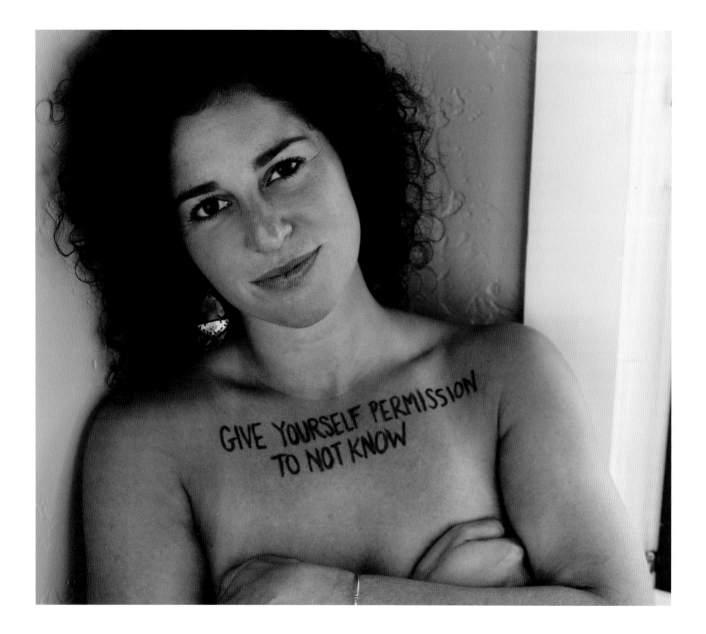

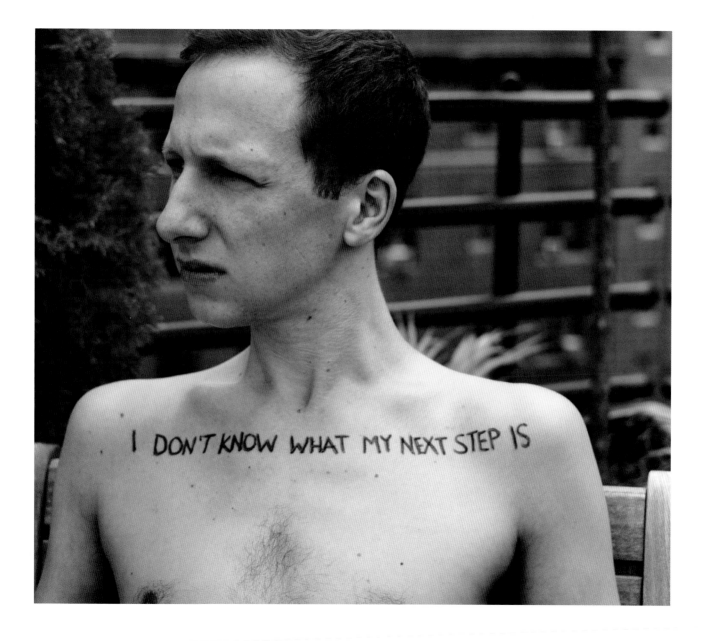

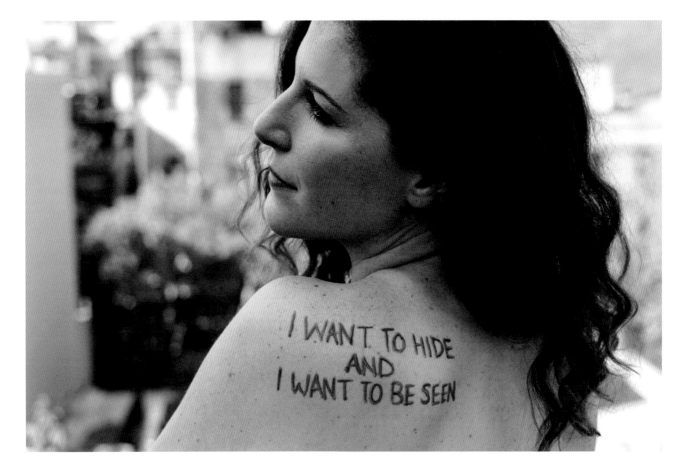

I'm a constant contradiction, vacillating between feeling confident and insecure. I hide behind other people's greatness. It's safer that way. Deep down I know I am cutting myself short. And truthfully, I would have never chosen a career in acting if I wanted to play it safe. Exposing myself is uncomfortable, but it's my truth and life's work and so I must reveal myself, layer by layer.

As far back as I can remember, I was always reminded of what a man should look like, talk like, be like, love like. And deep down, I knew I didn't fit most of those molds. I was constantly being fed images and standards of masculinity, beauty, and fitness I knew I would never live up to. So I became quiet, I stood in corners, always observing, always assessing how I should be. And I wrote, finding my voice, contributing to conversations in the best way I knew how to.

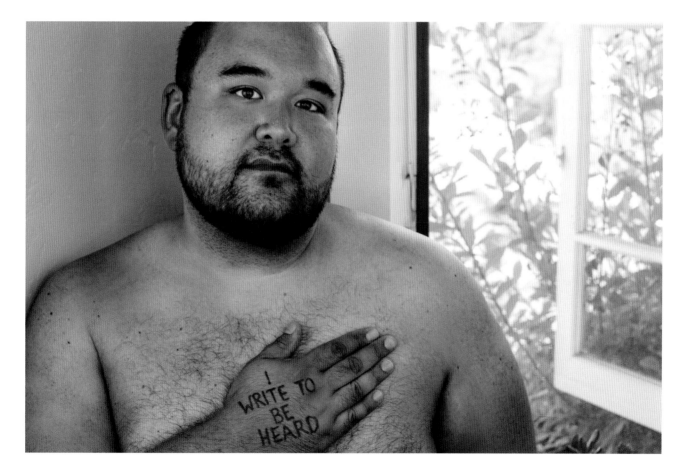

THIS IS A QUESTION I'VE BEEN ASKING MYSELF MORE OFTEN THESE DAYS.

I'm not afraid to admit I am a people-pleaser, but so often that quality of mine has left me in the dust. When you start molding yourself to fit another's storyline, you will most likely find yourself lost and confused. So this is me taking my power back by waking up and realizing just how powerful I am. Don't let them put you into a box, love. It is possible to be more than just one thing. You have the entire universe inside of you. Look inside and you'll find *your* truth.

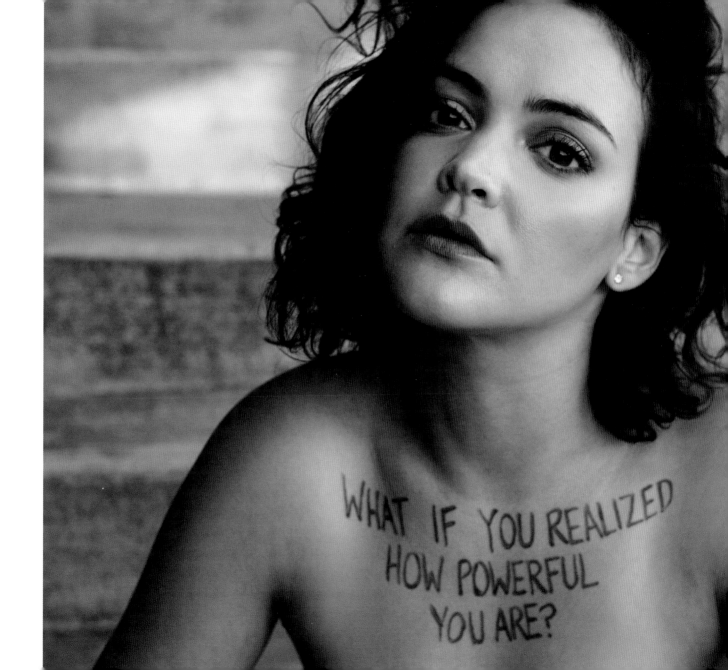

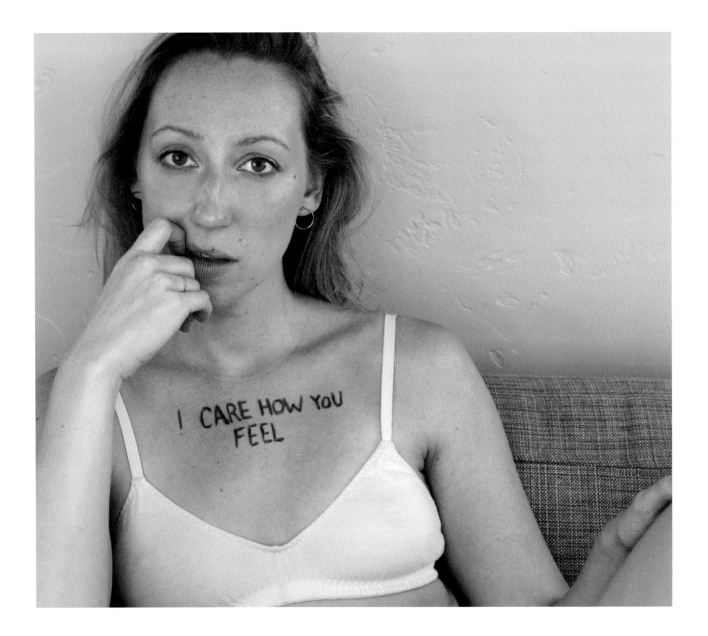

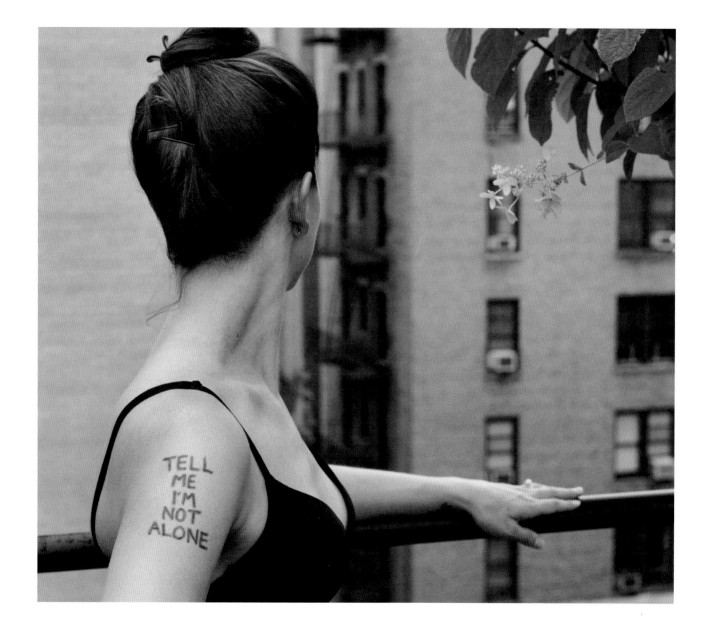

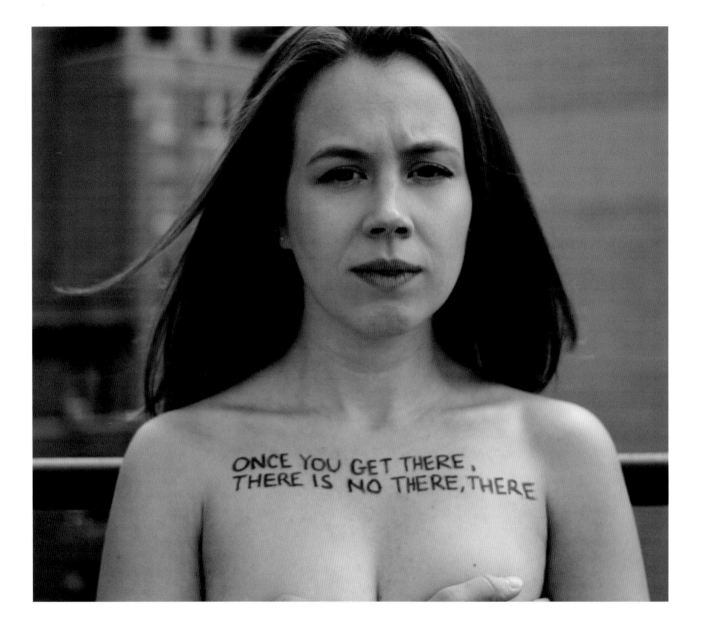

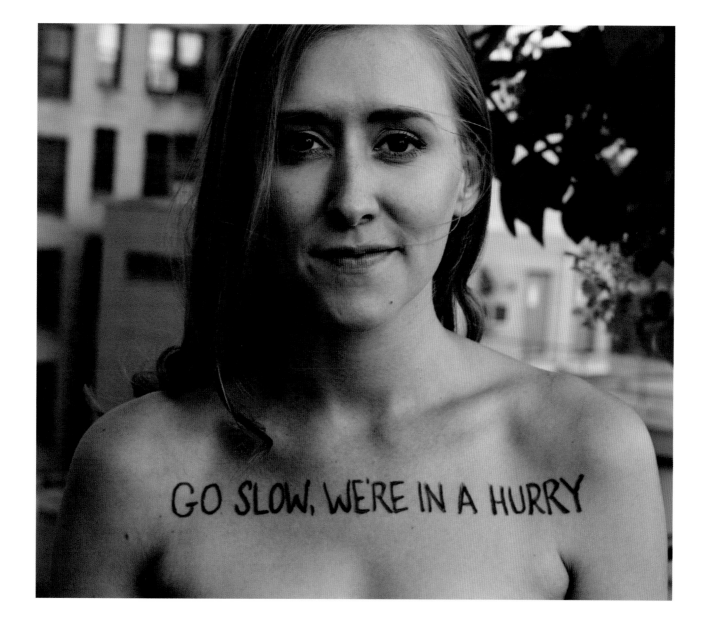

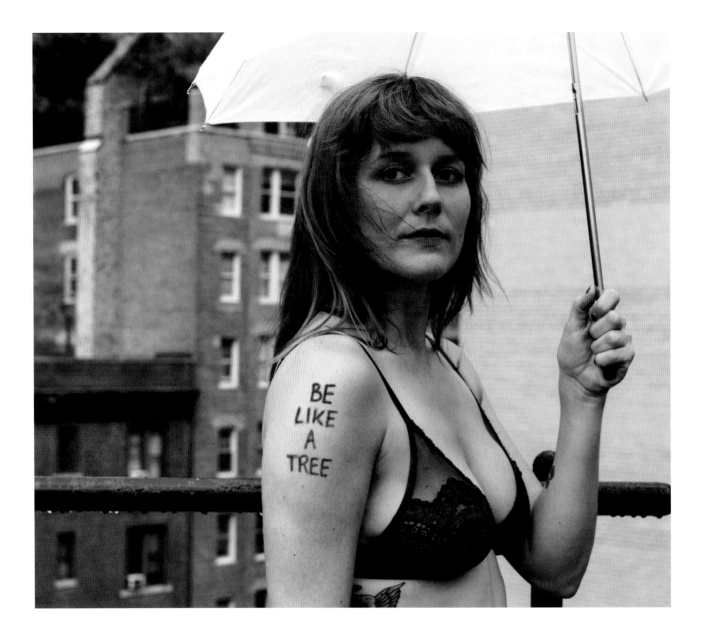

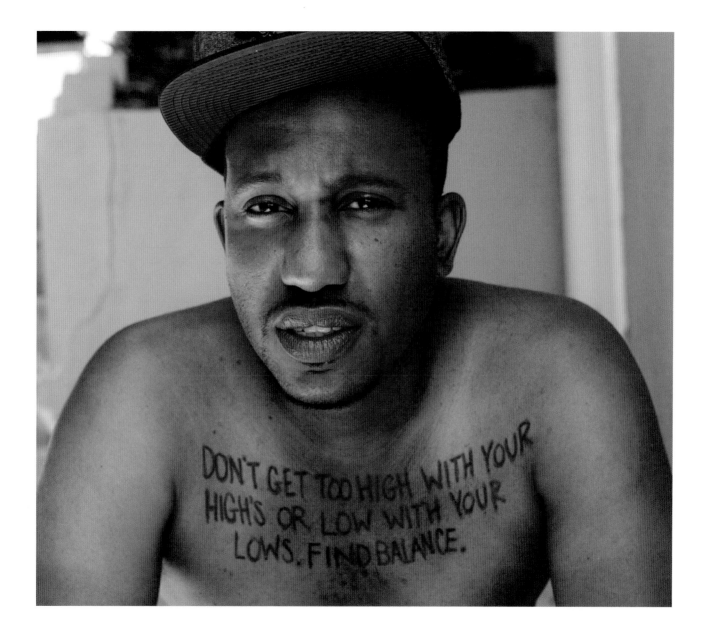

A LITTLE OVER FOUR YEARS AGO, I MADE THIS QUOTE MY LIFE MANTRA.

I've always been a people-pleaser and always tried to be inclusive. However, I found myself doing things I didn't want to do with people whom I didn't want to be around. At this same time, I was depending on attention and affection from others to bring me happiness. I took a step back and realized I know what brings me joy and I'm able to create and find that happiness in myself. It's my responsibility and I love it!

YOU ARE RESPONSIBLE FOR YOUR OWN HAPPINESS

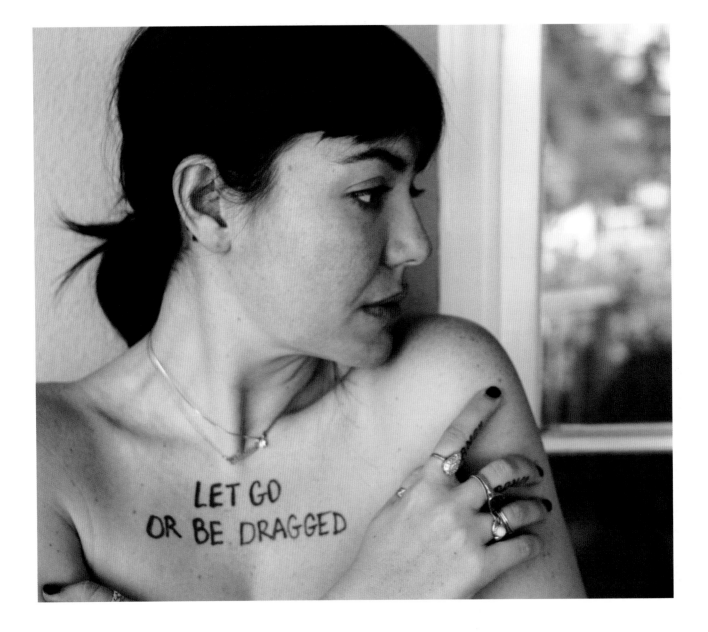

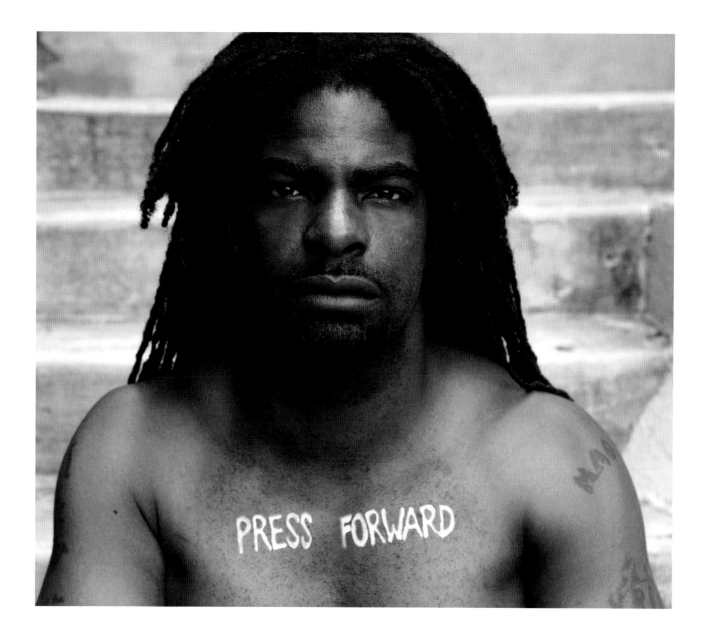

"Tiny" is greater than (or equal to) "strong." It never ceases to amaze me how many people underestimate the strength of tiny people like me. Men on the streets of Manhattan think it's okay to catcall and harass me because I'm small. They become angry when I ignore them because "little girls (like me) should appreciate it when big men want to protect them." If only they knew that I was certified to wield a sword or that I've been raised to be independent and tenacious. Or hell, that I might not need as much protecting as they think, plain and simple. There's a reason my winged eyeliner is so sharp.

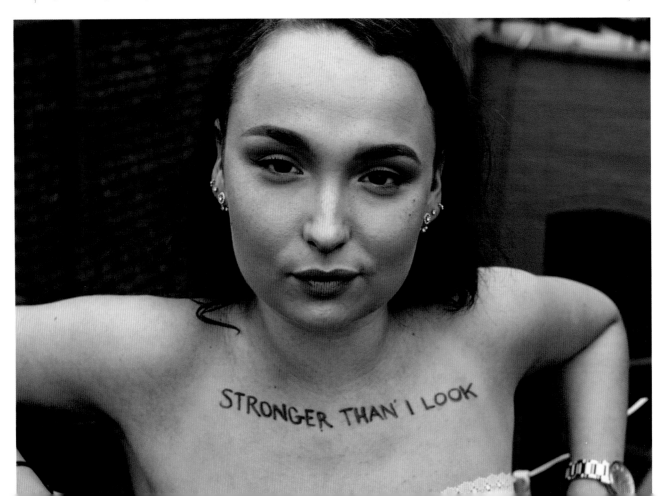

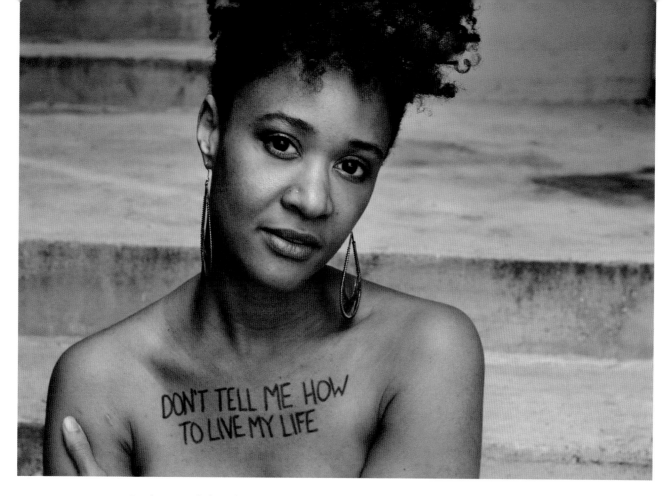

I am a rule breaker. And I am a black, queer woman in America. That feels dangerous. It feels unwelcome and unwanted. I chose these words for anyone else feeling scared, angry, or unwelcome as a reminder that we exist, and we're badass.

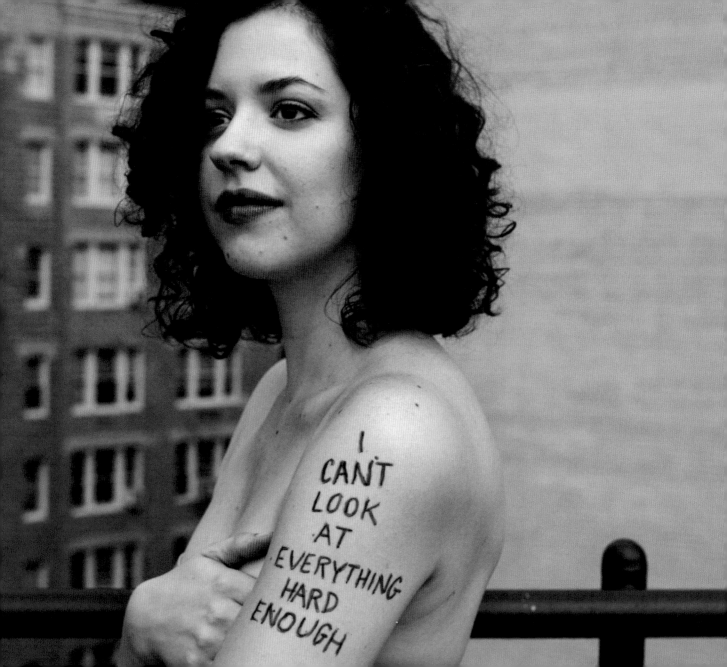

I AM STILL STRUGGLING TO
FIND BALANCE IN MY LIFE AS
AN ARTIST, BUT THESE WORDS
ALWAYS REMIND ME TO LOOK UP,
AND TAKE EVERYTHING IN.

Every moment in this life is precious, and when I take
the time to reflect on that, every little thing around me
becomes beautiful.

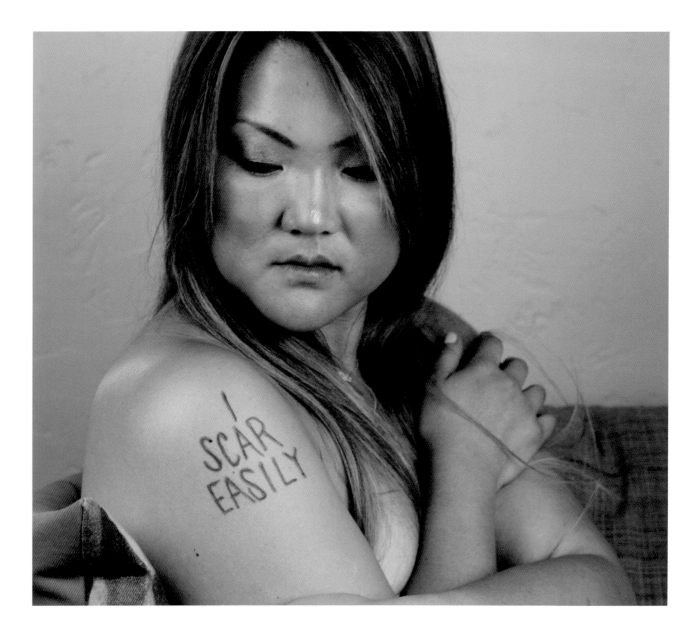

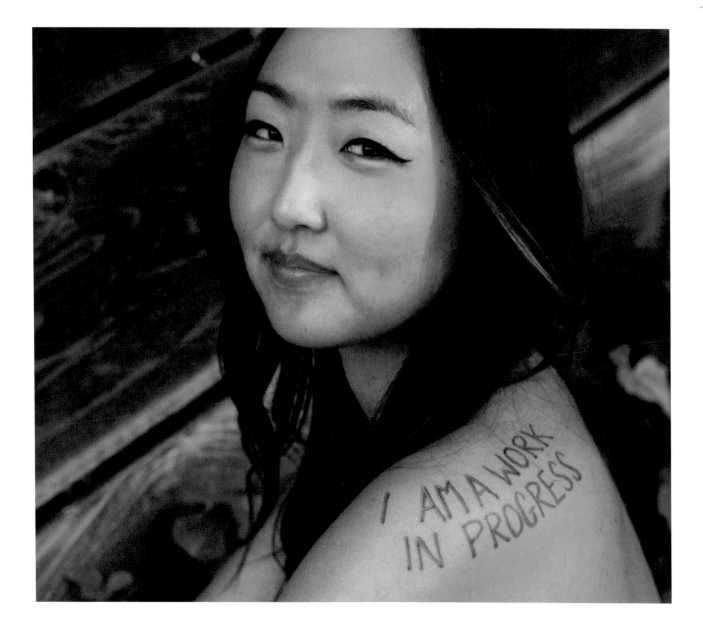

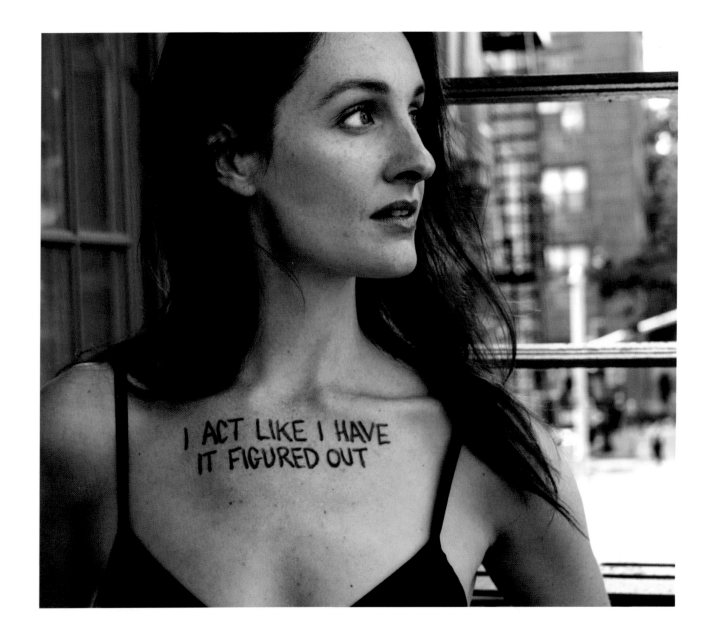

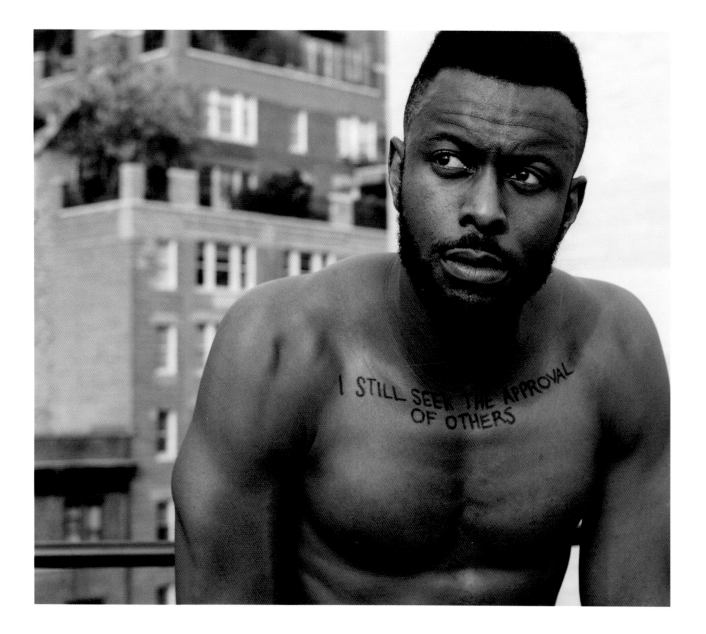

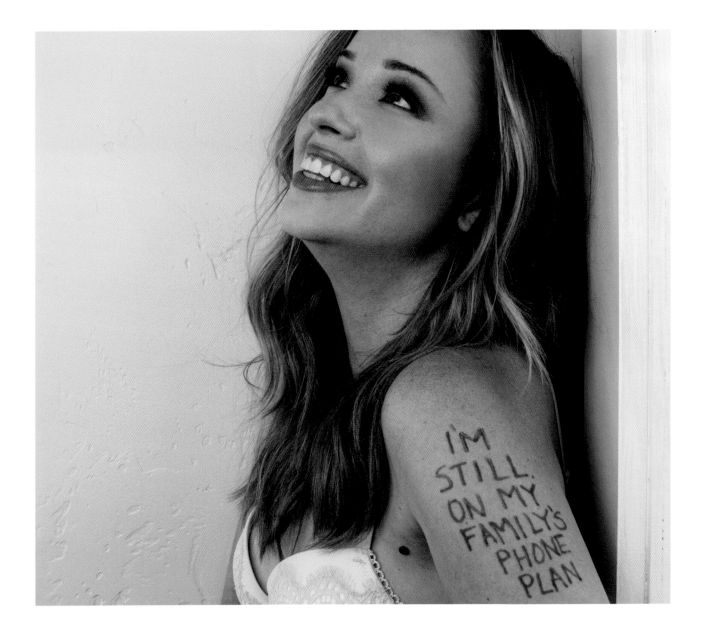

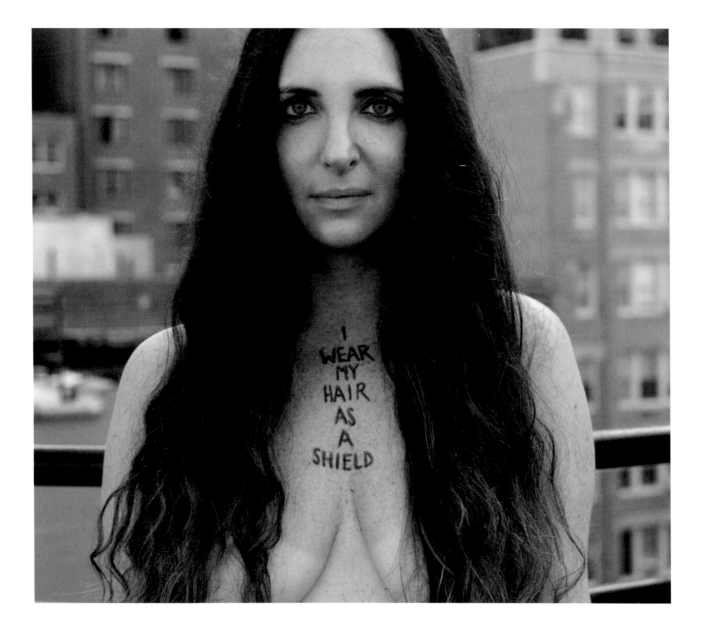

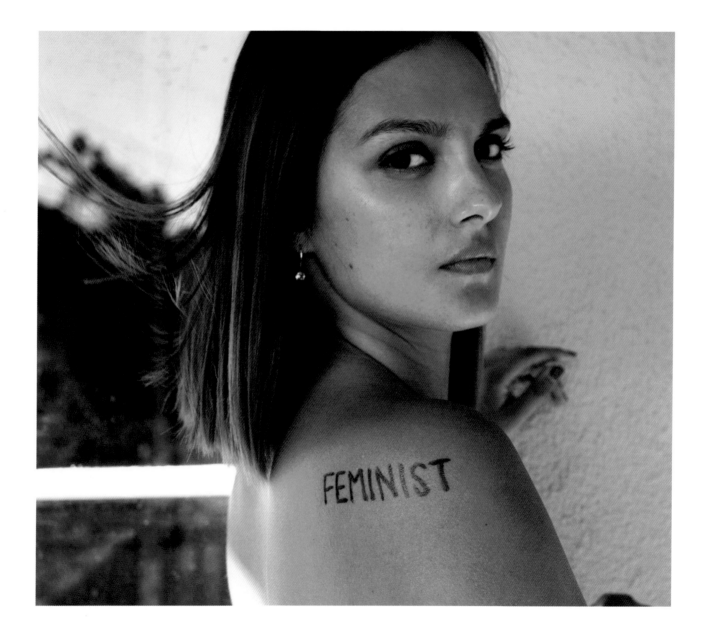

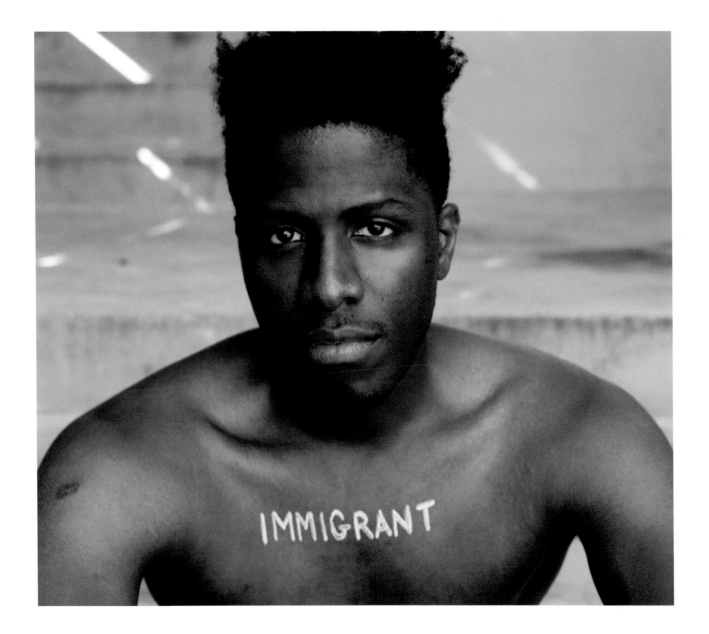

I AM SPECIAL AND AT THE SAME TIME, JUST LIKE EVERYONE ELSE.

I have hurt people. I have been hurt. I have worked hard. I have had trouble getting up in the morning. I have suffered and I have danced among the stars. Through it all, I just keep coming back to this one thing: We are *all* perfect in our imperfection. When I started really loving myself, my world shifted—as if the cycle of lows and highs broke apart. I just try to live every day grateful for life and every living thing that surrounds me. In gratitude, discipline, and love lies freedom. I am light and so are you. It's just sometimes we forget. And that is okay, too.

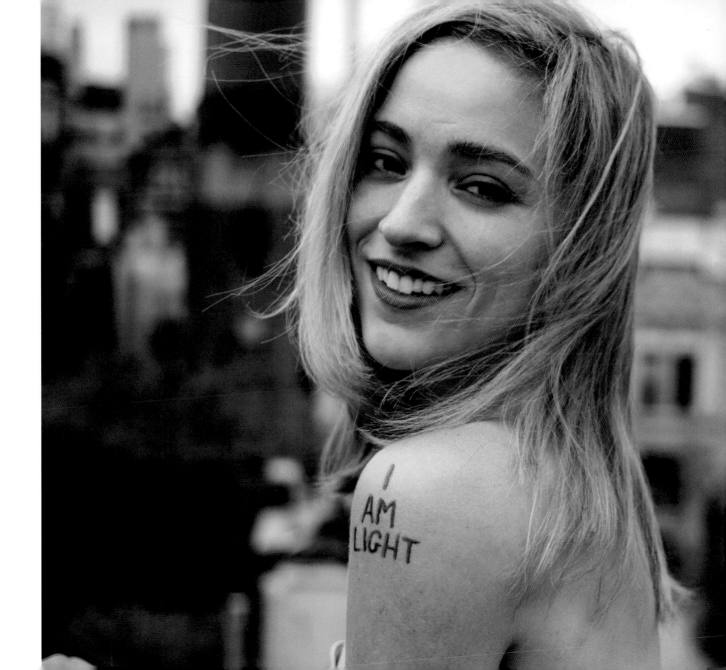

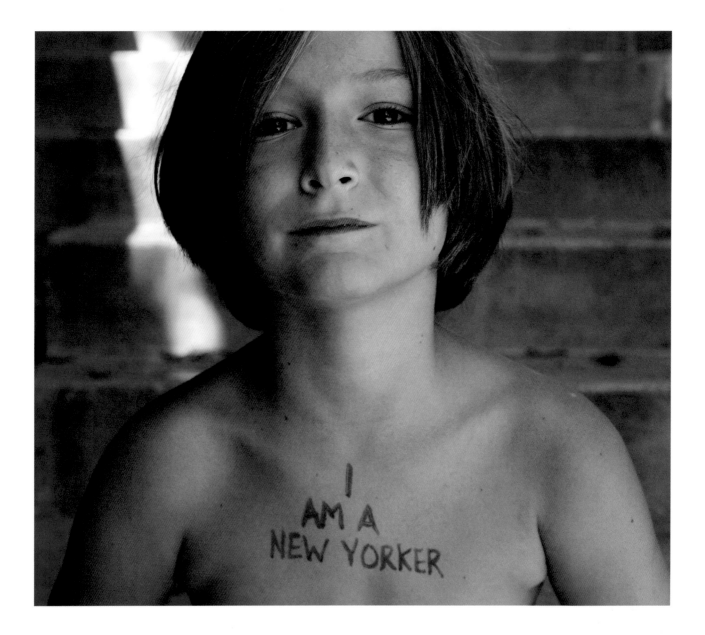

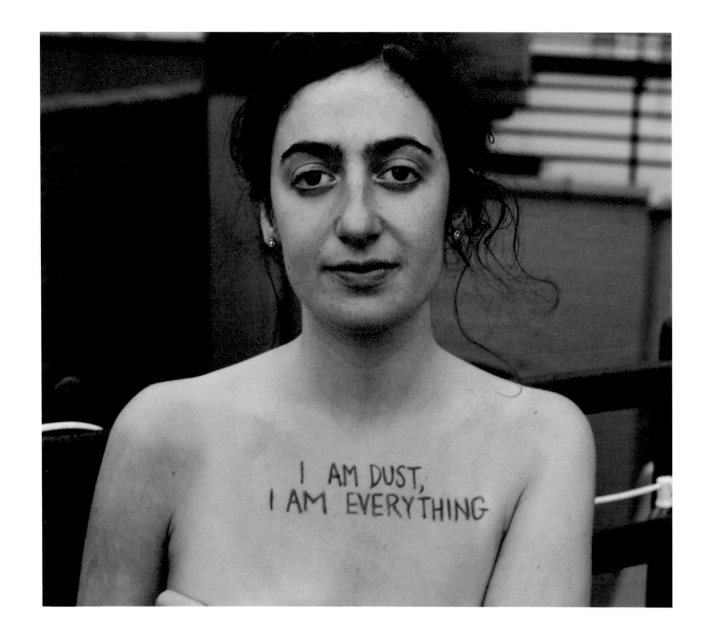

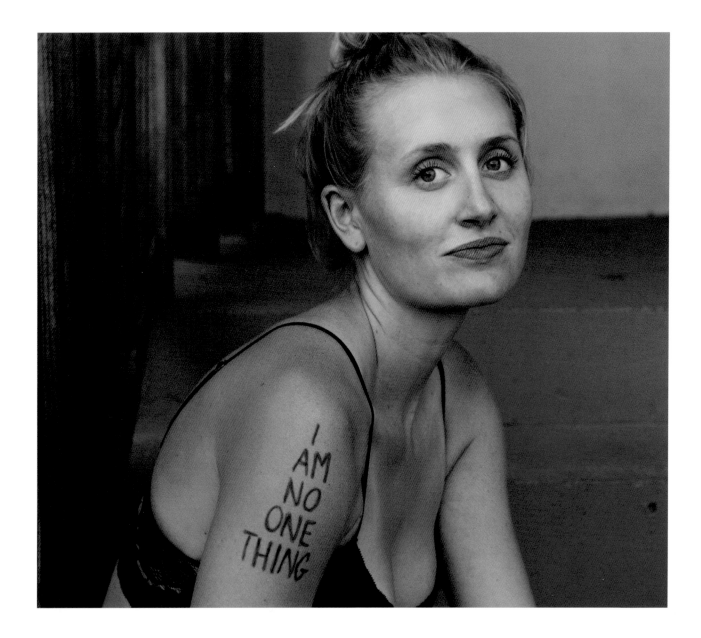

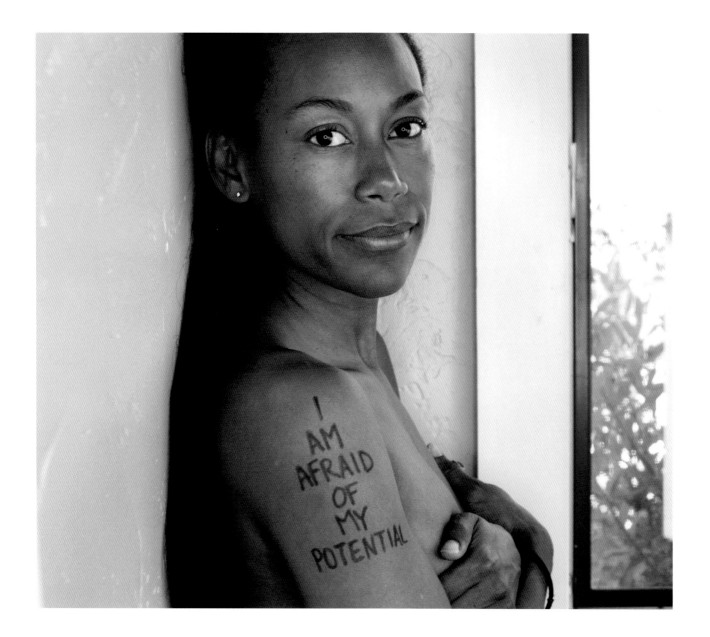

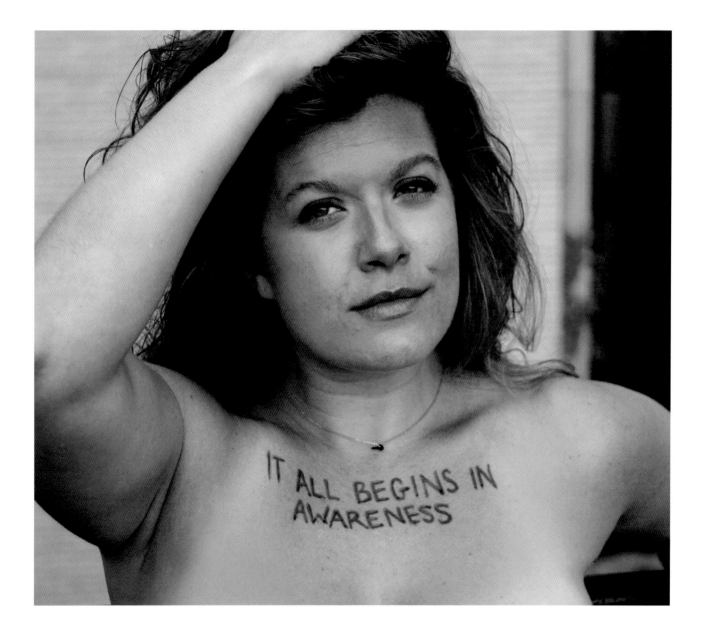

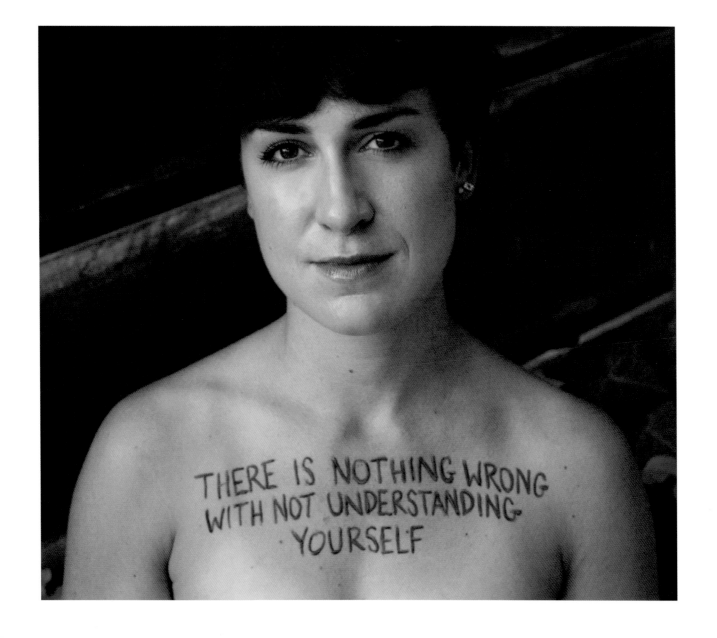

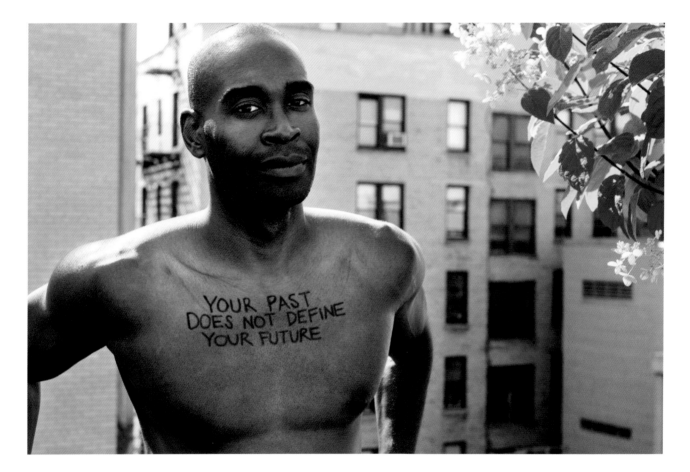

I may have inherited the stormy weather of my mom's and dad's choices, but I was also gifted with an inner desire to achieve greatness. I decided that childhood abuse, neglect, and homelessness would not define me. Somehow, I instinctively knew that there was more to my life journey. As I let go of victimhood, I began to put my past in its proper perspective. The clarity I gained from acceptance allowed me to shift into a conscious space of gratitude. Today, I live in the present moment with a humble knowing that if I move with love and intelligent purpose, my future will reflect the harvest of my daily habits.

I believe in inside-out wellness. Accepting my own healing process—including the shame, fear, and doubt that often accompanies it—has gifted me the capacity to connect with compassion. Whether you are fighting a battle within or experiencing injustice in the world, I will be a safe space. I will humbly listen to your truth with integrity and grace. I will lead with love. You are safe here.

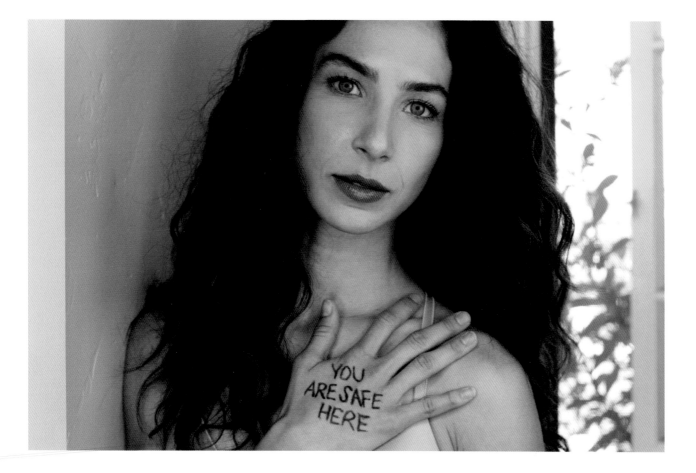

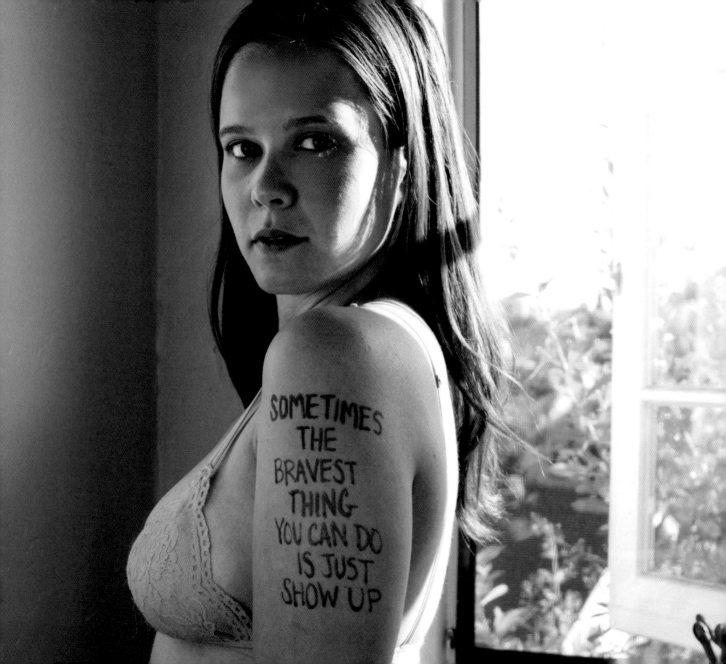

THESE WORDS HAVE HELPED ME MANY TIMES
WHEN I FELT LIKE HIDING UNDER A ROCK
AND NOT MOVING FOR A GOOD WHILE.

They remind me that sometimes the most courageous thing I can do when I am feeling vulnerable, sad, or afraid is continue to say yes to things. And that doesn't necessarily mean always in big ways. It can be small; like peeking out from under the rock and going to a yoga class or meeting a friend. Or allowing myself to experience sadness, anger, or fear instead of running screaming away from it.

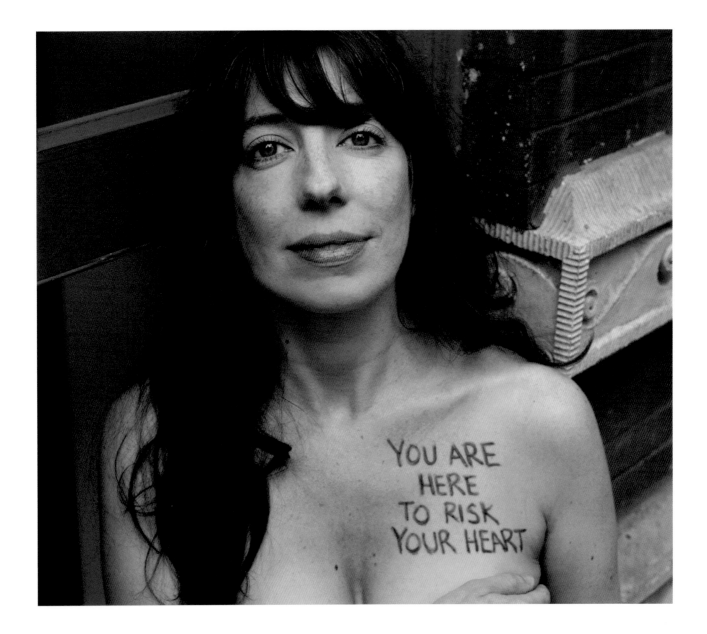

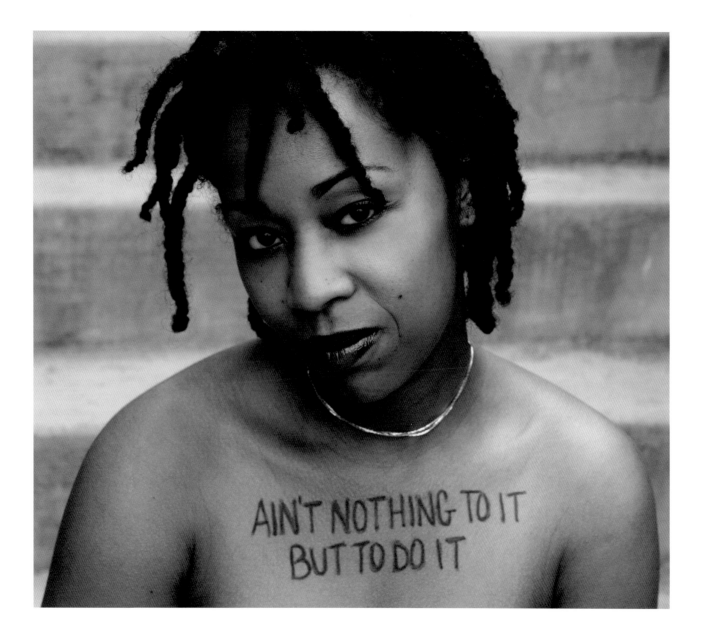

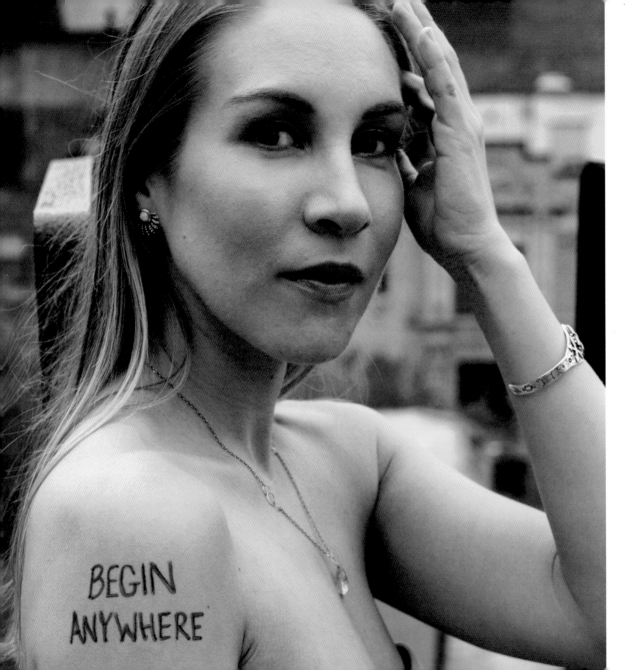

If I could give you my own personal collection of quotes and advice, it wouldn't be enough. You are about to be filled to the brim with words of wisdom and personal confessions and advice from over two hundred dear friends, dearer strangers, and fragile, stunning humans just like you. This hodgepodge of enlightenment can be the place where we turn when we need some guidance. It can be our cup of tea from which we can endlessly sip together.

MY NAKED TRUTH
IS THAT I AM LOST,
I AM FOUND,
AND I AM EVER CHANGING.
WHAT IS YOURS?

Adrien

This is what I can tell you about me: I am an actor. I am a cook. And I am also a photographer. I can talk your ear off, but I can also listen deeply and lovingly. I live for a good cup of coffee in the morning. I revel in inviting friends and strangers into my home. I fall in love so hard it has made me physically ill at times. But when I move on, I move the fuck on. I want to travel to Spain by myself and then Japan next. I finally feel like Los Angeles is my home, but New York City is my crazy ex that I will never quite be done with. I now work in an office and make a salary, but no title or credit will ever define me as a person. I believe women need to lift each other up at every turn. We all deserve equal pay, great health care, and strong female mentors. I think immigrants are the lifeblood of this country. I believe in racial equality. Black lives matter. LGBT rights matter. I once thought that being "lost" was a feeling for people in their twenties. I now know that being lost is ageless and sexless. And most importantly: If I ask questions, listen, and put down my damn phone, my heart will grow.

Many people live their whole lives without ever being asked a personal question. I have been so lucky to be able to ask questions so easily—and that, in and of itself, can be a calling. It's no small potatoes that I have the capacity to share. When I reveal to someone that I am lost or hurting, it allows the other person the safety to say the same. With that, I challenge you to ask the simple question of "How are you?" more often. Please listen deeply and make eye contact lovingly. Empathize. Cheer someone on. It may just crack your soul open.

he was making a fortune in his current profession. In Portland, I met a savvy woman who taught me the ins and outs of traveling on a budget, and I still use her wisdom today. In Chicago, I met strangers who, without hesitation, uncovered their deepest secrets within the first few minutes of our meeting. I even reconnected with old flames and long-lost friends. I sat across people experiencing tremendous pain and others who had finally found clarity. I spoke with cancer survivors, immigrants, rape victims, and victims of hate and racism. I met a group of yogis who reminded me that everything I could ever need is beating within my rib cage.

Together, we found connection and relief at every turn. There was such fearlessness in each person I spoke with. I was so impressed at their willingness to reach out to me personally and then offer up the words that make them feel most vulnerable. Quickly, I realized this project's mission was no longer about my search for clarity. It was about *our* search for clarity. Clarity comes when we fearlessly reveal the parts of ourselves we aren't usually willing to share. We are all lost in different ways. But if we shout it to the rooftops that we are in search of something, others can help us find it.

The simple act of conversation and hearing people's stories was balm for my soul. As human beings, we are wired to connect to each other—to gather, to empathize, and to care for people. This is why tribes, families, and groups exist. It was through those tales of brokenness, passion, and humanity that I was able to learn more about myself than I had in my adult life.

With my own word collection failing me, I thought about friends and family who also turned to novels, poems, and songs for guidance. Maybe they could help me find some new insight and add to my collection. With little dignity left, I picked up my phone and announced on social media that I was in search of quotes and sayings that have lifted others. Comments popped up within seconds. "If opportunity doesn't knock, build a door" by Milton Berle. "I'm a free spirit who never had the balls to be free" by Cheryl Strayed. Responses and messages poured in.

Within weeks, friends and family had showed up at my doorstep with notebooks in their hands ready to share their words. I didn't have much—just a camera, a washable marker, and the desperate need to connect with people. I decided to write each contributor's words gloriously across their chests, backs, and arms. I felt like a teenager again, daring to deface human skin with beautiful pieces of wisdom. As I posted these photos on Facebook, I found that others became inspired by this work. Days and weeks went by as new people arrived at my door, with sacred texts in tow, asking to be drawn on.

Originally each session involved a trading of favorite quotes and passages but organically, people began to share personal stories. Each tale was more moving and complex than the next. Friends introduced me to strangers, who, in turn, introduced me to their friends, and before I knew it, I had sat across over two hundred beautiful souls who opened their hearts to me. My first official session was with a woman who had fallen out of love with her husband. There was a man who was unsure of his calling in life, even though

feel the world's pressures piling up like rocks on my chest. The idea of a nine-to-five job, a serious relationship, and a savings account felt like the opposite of what I wanted for my "life goals." My hopes and dreams fell more in line with eating pasta al fresco in Italy, even though there was no way I could afford to do so. I dreamed of dinner gatherings at home with friends where we ate my famous Almond Ricotta Torte while connecting over hopes and regrets. I longed to experience a love that was deep, but filled with passion and unexpected turns. I wasn't attracted to men who offered stability. I craved adventure and mischief. But mostly, I wanted to be creative without a label that pigeonholed me into being just an actress. I felt like so much more than that. Using my art as a way to pay the bills began to suck the joy out of what was once cathartic and exhilarating for me.

After careful consideration, I decided to stop auditioning and turned to cooking—one of my other loves. I enrolled in a culinary program and eventually landed a job in an office kitchen where I cooked and cleaned for a staff of seventy people. After several years of what was mostly restocking cereals and cutting up fruit, my belly ached again for something more. Night after night, I sifted through my quote collection in search of a sign to tell me what to do next. All of my favorite phrases had lost their meaning. Endless questions buzzed within me. What if I don't have a calling? What if true, adventurous love is not in the cards for me? How do we live enriched, full lives alongside the world's pressures? What am I here for, anyway?

Introduction

FOR AS LONG AS I CAN REMEMBER, I HAVE HAD
A MAGNIFICENT CRUSH ON WORDS AND THE
WAY THEY CAN TRANSFORM A PERSON.

But it didn't take long to discover that writing was not my strong suit, so I committed myself to collecting all phrases that uncovered a feeling I couldn't find the words for myself. I've recorded conversations, ripped pages out of books and magazines, and copied down poetry and lyrics wherever there was free space to write. In high school, you could be sure to find me in the back of the classroom scribbling mantras on my hands and feet. Elizabeth Barrett Browning's "Light tomorrow with today" was scratched under my shoe. Shakespeare's "Nothing will come of nothing" was written in pen between my fingers. I have referenced great writers in letters to friends and lovers. I've read quotes and poetry out loud at celebrations and whispered comforting sayings to myself when depleted with grief. It is this stockpile of brilliant writing that has dragged me out of heartbreak, hurled me into uncharted waters, and grounded me when all seemed pointless.

It was in my mid-twenties that words started to lose meaning for me. It didn't happen all at once, but I felt a slow, steady, burn as I settled into my life in Los Angeles as a young actor fresh out of college. In my attempt to create a fulfilled "adult" life, I could

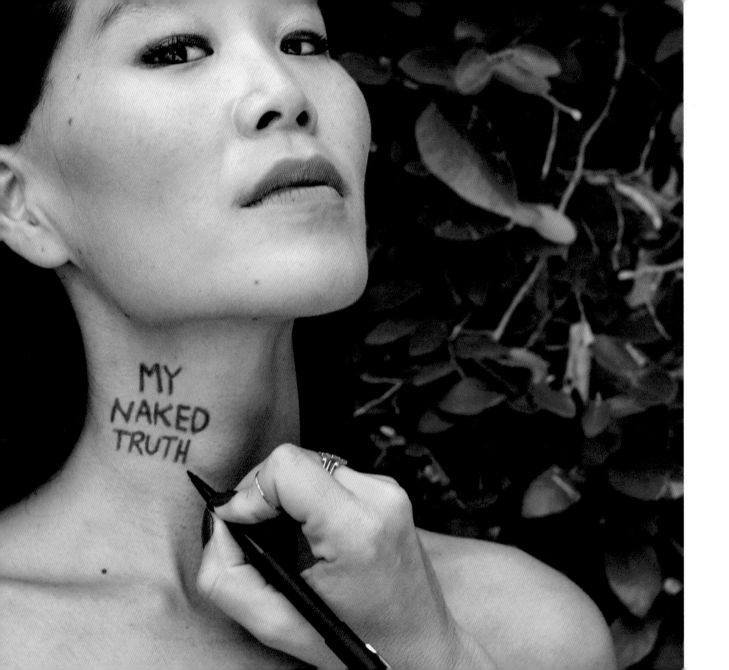

My Naked Truth

CITADEL PRESS BOOKS are published by
Kensington Publishing Corp.

119 West 40th Street
New York, NY 10018

Copyright © 2018 Adrien Finkel

Design and production by
Koechel Peterson and Associates, Minneapolis, Minnesota

All Kensington titles, imprints, and distributed lines are available at special quantity discounts for bulk purchases for sales promotions, premiums, fund-raising, educational, or institutional use.

Special book excerpts or customized printing can also be created to fit specific needs. For details, write or phone the office of the Kensington sales manager: Kensington Publishing Corp., 119 West 40th Street, New York, New York 10018, attn.: Sales Department; phone 1-800-221-2647.

ISBN 13: 978-0-8065-3890-7
ISBN 10: 0-8065-3890-2

First Citadel hardcover printing: October 2018

10 9 8 7 6 5 4 3 2 1

Printed in the United States of America
Library of Congress CIP data is available.

First electronic edition: October 2018
ISBN 13: 978-0-8065-3892-1
ISBN 10: 0-8065-3892-9

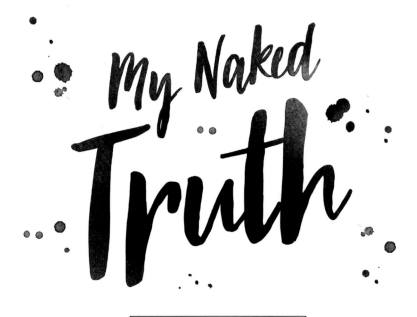

My Naked Truth

ADRIEN FINKEL

CITADEL
PRESS

Kensignton Publishing Corp.
www.kensigntonbooks.com